PROGRESSIVE/DJENT
STIJN MOREELS
DRUMMING

INTRODUCTION

Hi!

First, I would like to express my gratitude because you took the time and effort to buy and read this book. The purpose why I write this book is to give you (and myself) a greater view about the Progressive (metal) and Djent drumming, and to have a summary of all the different techniques I use to write music.

This is no complete guide to Progressive music because this genre is just to great and evolving that there would probably never be a complete book about this topic. This book is most of all an introduction for the advanced drummer to **Djent** music and the different approaches and techniques YOU can use to write your own music.

The book contains several systems and patterns to achieve this goal. I found it always kind of useless to list static patterns and exercises because this will cause a trapped vision and less motivation to be creative.

Because that's really the key in modern drumming.

Prerequisites

Before we get into it, let's go over some prerequisites.

All the music is written with the following schema in mind. The grooves itself are sometimes played with the leading hand on the Hi-Hat but feel free to change any setup. It's for readability reasons that every groove is almost played on the Hi-Hat so you can see clearer what the groove is all about.

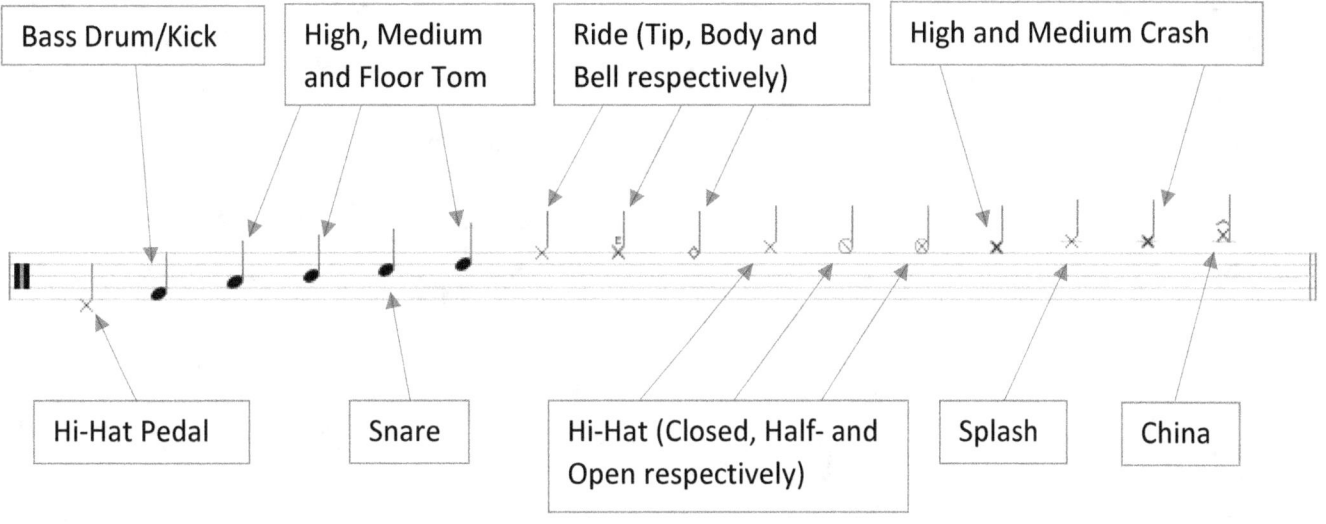

TABLE OF CONTENTS

Introduction ... 3
 Prerequisites ... 5
Values ... 13
 Dynamics .. 13
 Technique ... 13
 Complexity ... 14
 Variation ... 14
 Music .. 14
Principles ... 17
 80% Practice, 20% Talent ... 18
 Sound Like Yourself .. 19
 Mind the Captain .. 20
Practices .. 25
 Ghost Notes ... 27
 Filling Ghost Notes .. 29
 Supported Ghost Notes .. 31
 Long Ghost Notes ... 33
 Hi-Hat Patterns ... 35
 Hi-Hat Off-Beat Patterns ... 36
 Hi-Hat Permutation Patterns .. 39
 Hi-Hat Supported Patterns ... 47
 Hi-Hat Interaction Patterns .. 49
 Linear Structure Patterns ... 52
 Standard Linear Patterns .. 53
 Broken Linear Patterns ... 55
 Tom Patterns ... 56
 Tom Interaction Patterns .. 57
 Files .. 58
 Odd Signatures .. 59
 Explicitly Odd-Signatures ... 60

- Implicit Odd-Signatures ... 61
- Bass Drum Patterns .. 62
 - Leading Bass Drum .. 63
 - Decorated Bass Drum ... 64
- Music Structure Patterns .. 65
 - Comeback Pattern ... 66
 - Climax Pattern ... 67
 - Group Pattern .. 69
 - Break Pattern ... 71
 - Build Pattern .. 73
 - Alternative Pattern ... 75
 - Reference Pattern .. 77
 - Bridge Pattern .. 79
 - Surprise Pattern ... 81
 - Hold Pattern ... 83

Transcriptions ... 87
- Via Calypso – Lost ... 89
- Via Calypso – Orientation ... 90
- Via Calypso – The Incident ... 94
- Via Calypso – Exodus Pt. I .. 98
- Via Calypso – Exodus Pt. II .. 102
- Via Calypso – Greatest Hits .. 106
- Via Calypso – Catch-22 ... 110
- Via Calypso – Not in Portland ... 113
- Via Calypso – …And Found ... 116

Epilogue .. 117
Acknowledgements ... 119
Notes .. 121

VALUES

What are values? My values that I will describe are the high-level elements that I really want to accomplish and I always look for when listening and writing music.

These are the very building block and the end goal I want to achieve in playing drums.

Of course, the **Timing, Coordination** and **Consistency** values are also (maybe the most) important values for every drummer. But this book is about progressive drumming and so I want to explain myself within this area. I assume that you already have practiced your timing, coordination, and consistency.

Dynamics

The value I find most forgotten is the value of dynamics. Bands that record their drum with a pure computer controlled system where every hit on the snare sounds the same really don't have the value of dynamics in mind for example.

Without dynamics, you lose almost every personal feeling in your playing. If you can't distinct two different sounds in the snare, how could you place any "human-touch" in your music?

Jazz drummers have sometimes a small drum set. That's because they don't need other cymbals or toms to play different sounds. It's by changing the volume of your playing that they add that extra layer of dynamics and personal feeling to the music and not by buying extra material.

Technique

The second value, is the value of technique. Before you start learning a solo of your favourite drummer, you should have a basic set of techniques you can rely on (real story). Do you know about paradiddles? Can you play flams? Are you using rolls in your playing? …

Rudiments are the very basics of all drumming in any genre but so many drummers forget about that and try to learn immediately the solo itself which may contain paradiddles, flams and rolls….

After that, playing shuffles, off-beat patterns, triplets, …

So much to learn!

Complexity

Complexity is my favourite value in writing music. I think I almost like every genre if it contains complexity in it.

Bands which constantly change time signatures, constantly change dynamics, … without it sounds like it's forced; that's my goal.

The Djent and Progressive genre has of course this as their primary value. It's because of their complexity that some band are called a Djent or Progressive band.

Variation

When writing music, I always try to entertain the listener. Adding variation is one of those values that really makes sure that this happens.

Instead of just replaying the chorus, could you add some parts that makes it more interesting? Could you add some variation with the first one?

Till this day, I have never encountered music that has suffered by adding variation.

Music

Finally, I must always remind myself that I'm writing music and not solving a math puzzle. The balance between complexity and music is sometimes hard to find. When you add complexity to your music, it can quickly sound like you're forcing some extra layer in your song.

My first encounters with writing complex music was that I just tried to put in too much and my songs sounded more like some exercises for practicing complex grooves instead of a song that you could play on your stereo.

Make it sound like a song.

PRINCIPLES

Before I go straight to the patterns, it might be useful to first explain some basic and simple principles that can help you understand more how I see the practicing of drumming in a whole.

Principles are like bridges that can link the values into practices. I think it's important that you first see what "practicing" really means in my point of view and what I have learned about sound developing.

I hope that after this book, you can define your own values that you hold high and the principles that you use to set them into practices.

80% Practice, 20% Talent

Something that my drum teacher once said to me (thank you btw for a phenomenal journey **Philip Carpentier**!) is that with drumming and possible other practices there's 80% practice and 20% talent.

Nobody is born with drumming skills and you may have got talent for drumming or may not but it's only is for that little 20%. If you practice, those 20% is nothing anymore.

Like everything, practice is important. It doesn't matter if it's just some *Single Strokes* you played or some *Timing Exercises* or maybe some *Coordination Practices*, if it's something, then it means something.

In practicing drums, I have a week-schedule to keep me on track.

DAY	PRACTICE	DESCRIPTION
Monday	**Consistency**	Consistency in playing grooves, fills…
Tuesday	**Timing**	Timing exercises, switch timing…
Wednesday	**Weekly Technique**	Could be anything: linear grooves, dynamic training, ghost notes…
Thursday	**Coordination**	Hand-Feet Coordination, polyrhythms, …
Friday	**Improvisation**	Practicing new elements during improvisation
Saturday	**Music**	Music writing/listening/playing
Sunday	**Hand/Stick Control**	Rudiments, Hand/Finger exercises

This is by no means a schedule that I follow every week. Sometimes I find it more useful to fully commit to a single technique a whole month straight. Sometimes I play the whole week coordination exercises, sometimes I play linear grooves when I planned something else, and so on…

I created a schedule to remind myself of all the things I find important to train myself in during my life and it's a very dynamic schema. I think I change it every week.

Sound Like Yourself

Too often I came across people that wanted nothing more than sound like some of their favorite drummer. The sound of the snare was just "perfect", the bass drum was that deep, ... When playing the songs of him/her they played it exactly like that with nothing more of personal flavor.

I hope you already see what I'm trying to say. I think it's very important that you sound like yourself and not like some other drummer. YES, it can be a good first step to take some sound or practices from others, I think everyone does that. But in the end, I think it's most important that you make your own selection of things you like and don't like.

Only then you can really be developing an own sound and a personal feeling with your playing.

If you like to play ghost notes, try them out in environments you won't expect, if you like to play on the Ride's bell try it in some songs instead of something else, if you just learned a new fill or system that you really like, try it out the next improvisation session you have...

By developing your own sound, you create your own personal way of playing drums. By listening to others, you can develop your own opinion about sound. If you're comfortable about the sound, then it's a good sound for you.

OF COURSE, this is a learning project. Drumming is a project. You will fail and succeed. Try to develop your listening skills on any kind of music and try to learn why someone sounds like that.

<u>My personal opinion is that every drummer can learn from every drummer about anything.</u>

Mind the Captain

Each genre has its own <u>captain</u> and by explaining this to you, it gets easier understanding the Djent genre but also other genres.

The following examples are just basic ideas to make a point, <u>this does not mean that each genre is limited by this rhythm</u>. It's just to have an idea of defining the captain in music.

Let's use following basic rhythm:

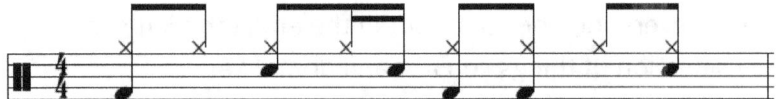

JAZZ VERSION

The Jazz version has it typical Ride pattern which in this genre is the captain. The genre is defined by it and is recognized by it. Without the typical pattern on the Ride, it wouldn't be even be a Jazz rhythm.

Some drummers call this "constant" in jazz because nothing (except for a fill maybe) may interrupt this Ride pattern; otherwise it will ruin the jazz-feel.

I have trained several Jazz rhythms and patterns but Jazz is not exactly the kind of music that I need to write so I'm not going to deepen this section. Just to show you the difference with other genres and what **Djent** has in common.

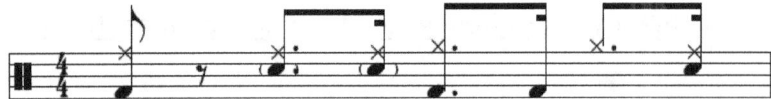

FUNK VERSION

The Funk version has its typical ghost notes and an extra a drag at the end (learned from James Brown). Funk is really about that ghost note and hi-hat/ride time keeping. These two are actually so important that even when there's no bass drum in it, it would still groove. That's why the two hands are captain in Funk drumming.

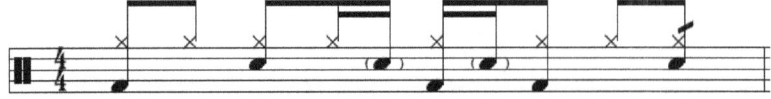

When I first started writing Progressive music, I found that Funk drumming has a very lot in common with Djent music. That's why I trained myself more and more in funk music to achieve this dynamic feel.

Djent (like Funk) is also about dynamics: the changing of volume and gain. <u>Which is an important</u> and a forgotten topic in the more aggressive genres. Djent is one of those genres where dynamics are very important and really defines the music you create.

A later section I will show you how to gain this dynamics in your playing.

METAL VERSION

To be complete, I also added a Metal version to the list. In this genre, the communication between the hands and the feet are important and therefore captain.

Metal is one of those genres that's evolved enormously and is still evolving in every possible direction. Nowadays, the number of different genres and sub-genres in metal is so incredible big that there's almost no overseeing possible.

Djent music is a sub-genre from progressive metal music, but it's much more than that. That's why a book is in its place.

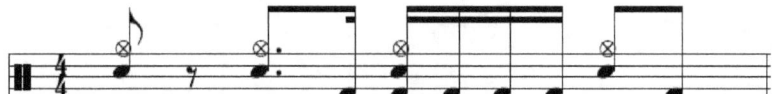

PRACTICES

Now we have gone through some values and principles, we can start with our practices. How are we going to practice all these principles for our values?

There are so many things I would like to explain to you, but I have limited myself to some very fun elements in writing and practicing Progressive Djent music.

Ghost Notes

Ghost notes are <u>very important</u> in Djent music. So important that I write an exclusive section about this.

To have you all on the same line: ghost notes are softer played notes and are marked in music with the brackets around the note "(o)". The definition of the ghost notes doesn't contain the <u>amount</u> of which the note is played softer so no boundaries there! Note that the key is dynamics!

Just like Funk has lots of ghost notes to have a full-blown rhythm, Djent has them for the same reasons; see for example patterns from **David Garibaldi**.

The two main reasons that I find it necessary to place Ghost notes are these: To fill the blanks and to "support" the accent. See how I use "support" because the ghost notes are captain and are in my perspective more important than the accent itself.

From: Via Calypso – The Incident

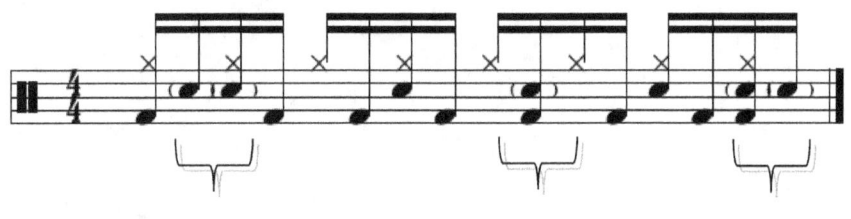

1) Filling the blanks 2) "Support" Accent 3) Bridge to begin

The first ghost notes are placed because otherwise the rhythm would be empty at the beginning. Not that there's something wrong with "empty" (**Less is More**) but in this context the rest of the pattern is filled with bass drums and the emptiness in the beginning would ruin the roll.

The second ghost note is place to get a relationship between the two accents (other snare notes) in the rhythm. When played, this ghost note is the "bridge" between the two accents.

And finely, the last ghost notes are the bridge to the beginning of the rhythm, this way the pattern can be played repeatedly and still roll.

The level of volume in which you play these notes is of crucial importance. Many people think that there's only one volume in ghost noting but that's a long way from the truth.

Jazz drummers can sometimes play around **40 different notes** on snare. This is reached by changing the volume of the note, the placement of the stick, the swing of your hand... and so on.

It's important though that if you play multiple ghost notes at the same space or around an accent, you must not let this interfere in any way.

Let's look at the following example:

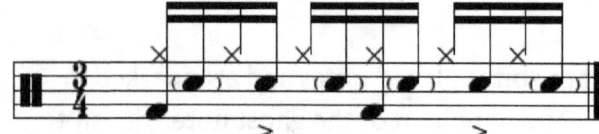

Don't let the accent interfere with the volume of the ghost notes! Try to get your hand close to the drum head after and before the accent!

On the next page, you find variations on the Hi-Hat, <u>please</u> use this in all other exercises in the book as well and not just for these patterns. It's always good to think further than the exercise.

Filling Ghost Notes

The most basic examples that you can use to learning ghost notes, are *Filling Ghost Notes*. Notes that literally fill the gaps. I think that it's a good starting point to introduce you in Ghost Notes. This way you learn how these notes interact with other parts without a bassdrum is interfering.

I think you could see this as a communication between the snare and bassdrum.

When you really start seeing the filling notes, you can easily add them to your playing. I personally add them to almost every groove I play (most of the time I'm not even aware that I added the notes).

Find the gaps in your own grooves and try to fill them with ghost notes.

Examples

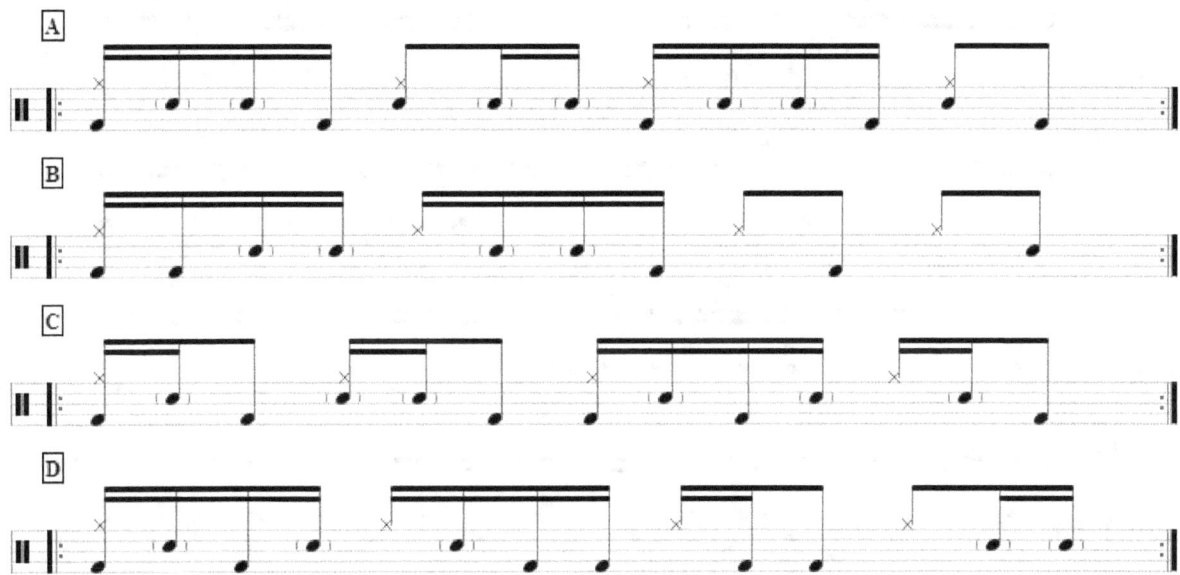

See how the ghost notes are "filling" the gaps. Try combine these grooves without the ghost notes and see how it dynamically fills the gaps.

Take for example the first one:

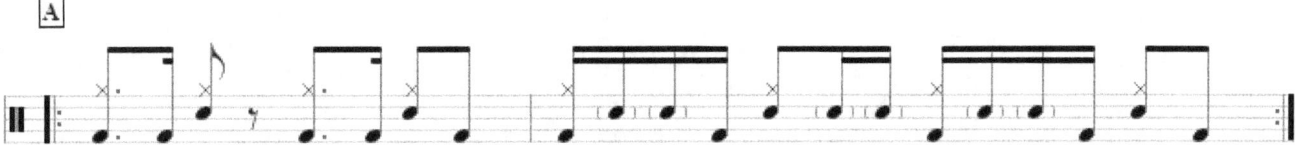

Advanced Exercises

Following exercises are some "advanced" grooves that you can use to find those empty spots and fill it with Ghost Notes.

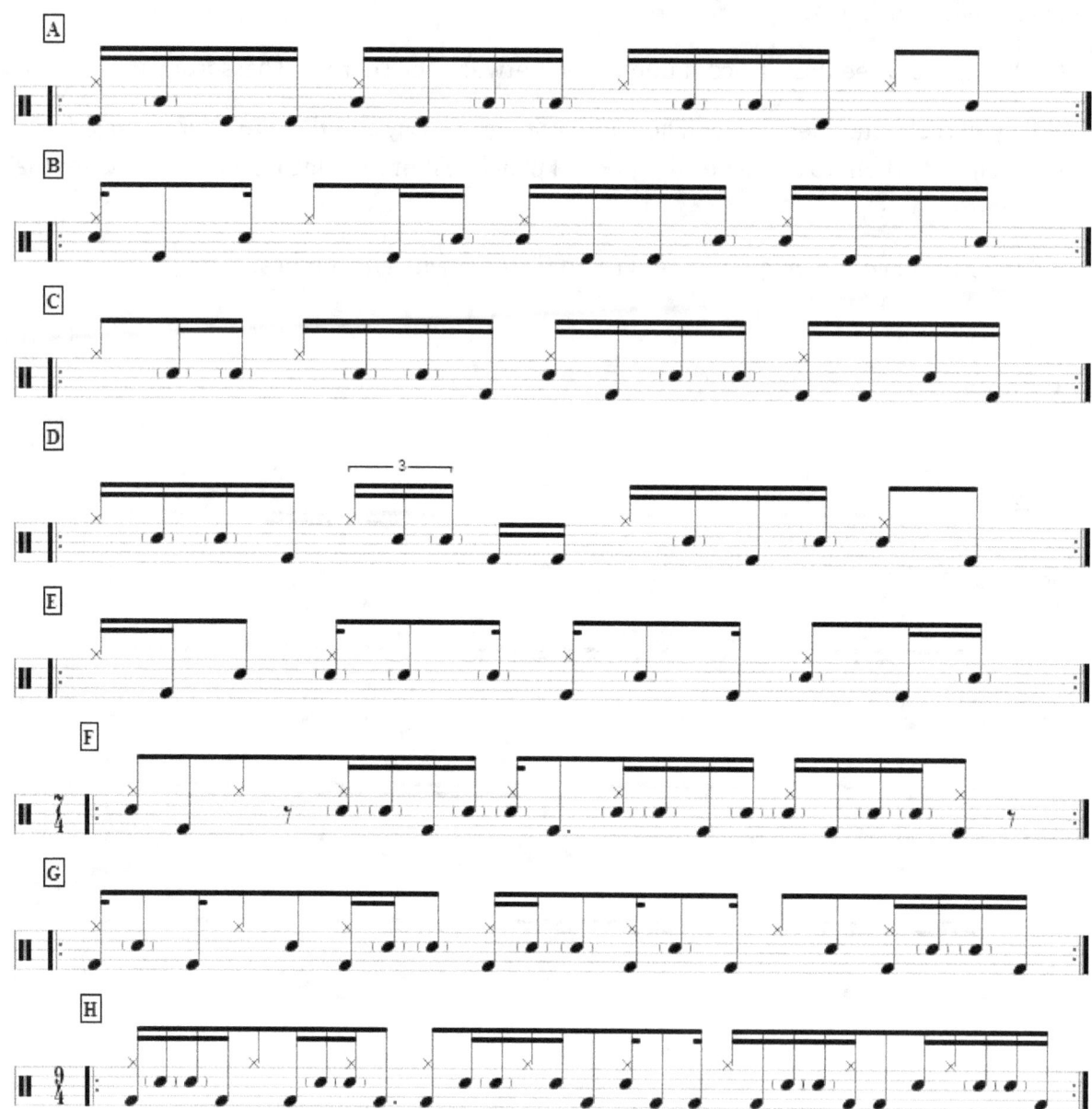

Supported Ghost Notes

The following patterns has some interesting supporting ghost notes. Like I said before, the supported ghost notes are there to "support" the accent in a way they take over a lot of work of the accent. It's crucial that you have a significant difference between a Ghost Note and a Regular or Accent, so you create as much contrast as possible.

Supported Ghost Note Practices

Personally, I use the following practice quite a lot when training ghost note patterns. The practice looks like exercises for the *Long-Ghost Note Patterns*, but I feel that when I play this practice; I'm practicing my ghost notes around the accent and not just the long batch of notes.

By practicing this example, you really train yourself to play a significant difference between an accent and a ghost note. Especially ghost notes that are played close to the accent tend to sound louder than notes that are far from the accent.

It's by playing these kinds of practices that you force yourself to really focus on the notes that are played as accents and the notes that are played as ghost notes.

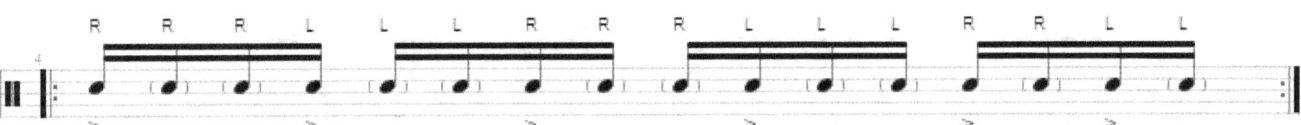

Now try to come up with your own version. Throw some paradiddles and play the last note as an accent (for example).

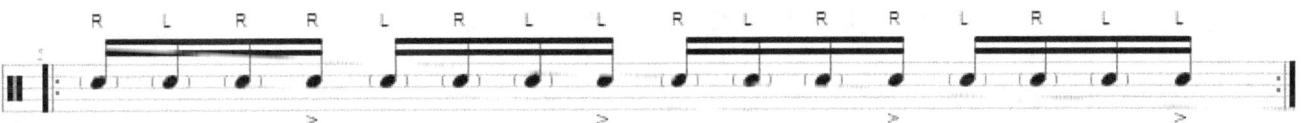

If you haven't bought the book **Stick Control**, you should buy it. It contains the most known rudiments and is one of the three objects that every drummer should need (besides sticks and a metronome).

Try this accent-ghost note practice with all these rudiments and you maybe find some interesting combinations.

Advanced Exercises

Following exercises are some examples of *Supported Ghost Notes*.

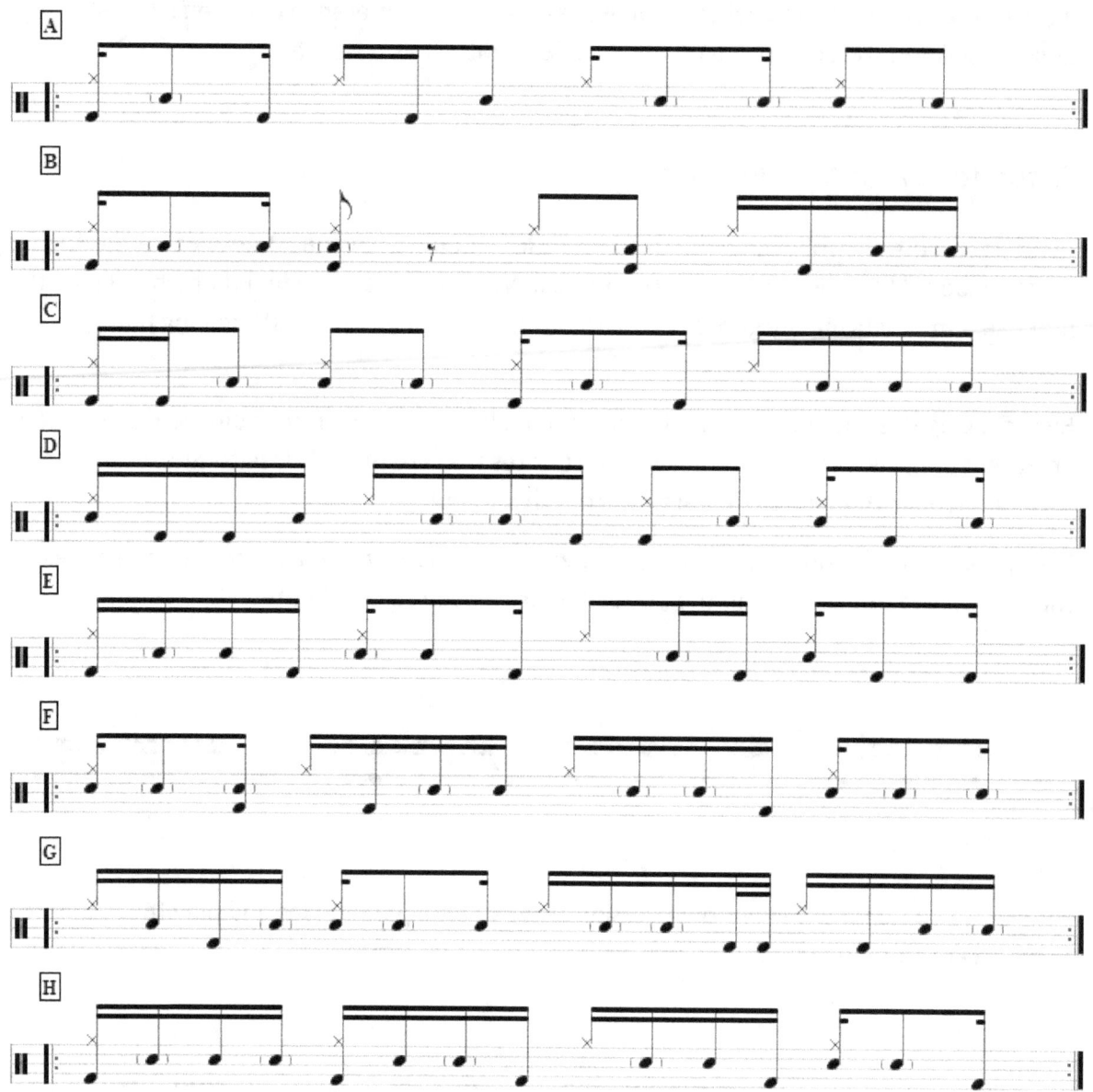

Long Ghost Notes

With "Long Notes" I mean longer than 2 notes. It was when I was playing to my own songs and other Progressive Djent songs, that I had the feeling that I needed a constant filled-up layer around the groove. **David Garibaldi** talks about this in 2 notes with bass drum notes, but I need sometimes a more consistent sound like 3 or 4 ghost notes. **James Brown** has several songs were 4 ghost notes are played together (*Funky Drummer*). So, I started experimenting with the length of the ghost notes I played and sometimes I play even 5 or 6 ghost notes together.

Before we jump right into the musical exercises, I'll first talk about some practices that can help you train your ghost-note skills (I play/practice with both hands).

Long Note Practices

Following practices are based on a single accent on the snare and three ghost notes surrounding it.

Let's take a loot at the first one (A): starting with a bass drum, then 3 ghost notes and a single accent on the snare; together makes 5 notes. The ride is played in a 4/4 signature so it shifts over this pratice.

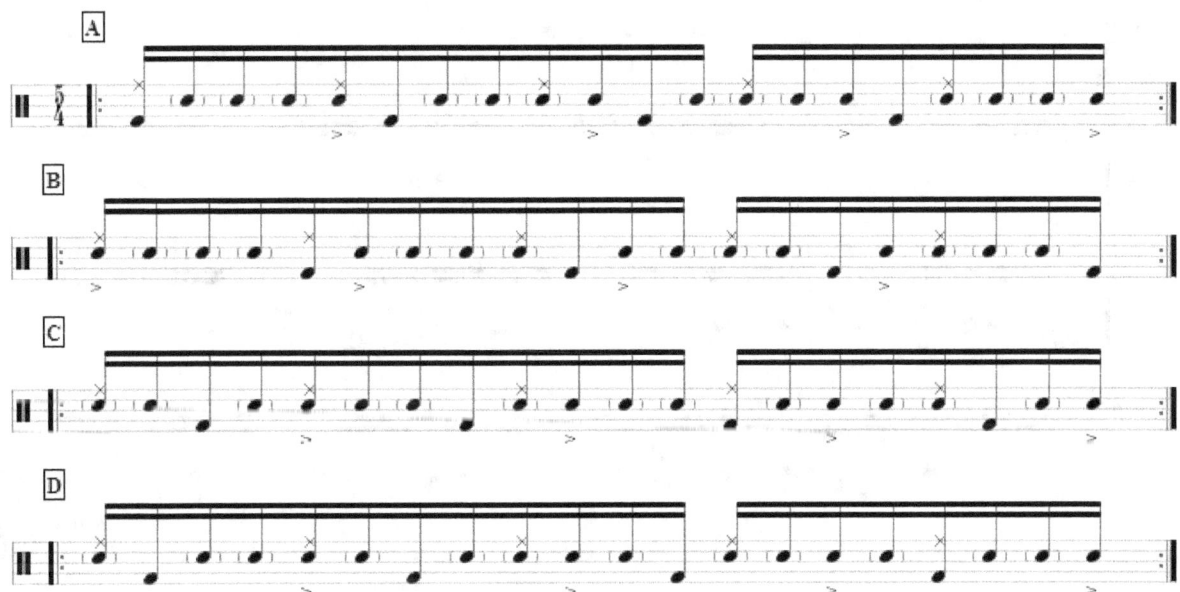

Musical Exercises

Following patterns are some exercises I use to train my "Long Notes" for Ghost Notes Patterns. You can really use anything of course, but these are a good starting point. The idea is to train your left (or right hand if you're a lefty) to become familiar with Ghost Notes (and long notes).

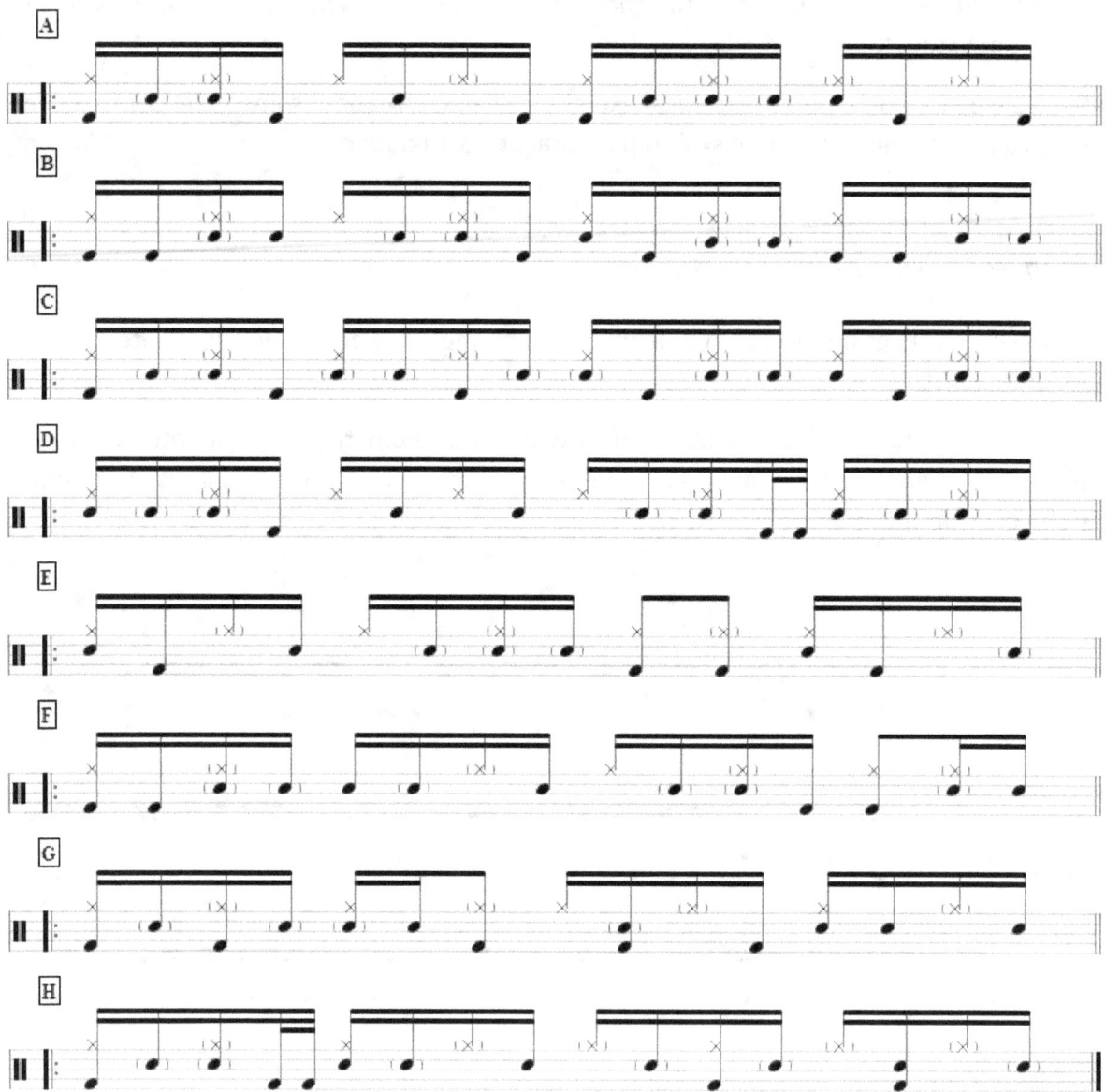

Hi-Hat Patterns

Like funk, the Hi-Hat is the **key** for music writing and composing in Djent music. It defines the feel of the groove and can make the groove sound more mature.

It's always critical for funk music that the parts must be played like it's a starters groove; make it sounds like it doesn't take any effort to play it. That's the key for funk music, and the key for Djent.

We don't want our grooves sound like it takes enormous effort to play it right, we would rather make it feel like it's what we play all the time.

The Hi-Hat is a part of the drum that really can make a difference in here and plays a part in this approach. Just by letting the cymbals lift off a little at the end of the groove or just before the back-beat transforms the groove.

The following patterns are examples that I use in different scenarios, each listed under a specific header: *Permutation, Interaction, Off-Beat...*

Hi-Hat Off-Beat Patterns

Off-beat patterns are always fun to play. They are very popular in the whole Dance culture, but they really are useful in the Djent genre.

The first time I encountered these off-beat patterns, I made the mistake to not adding much attention to them; but they are wildly used and are the first step in my opinion to the permutation and the polyrhythmic feeling of drumming.

Advanced Off-Beat Exercises

Here are some "advanced" *Off-Beat* exercises to train your off-beat skills. These exercises are played with the right hand on the Ride's bell because some have Hi-hats notes in them (played with the left hand).

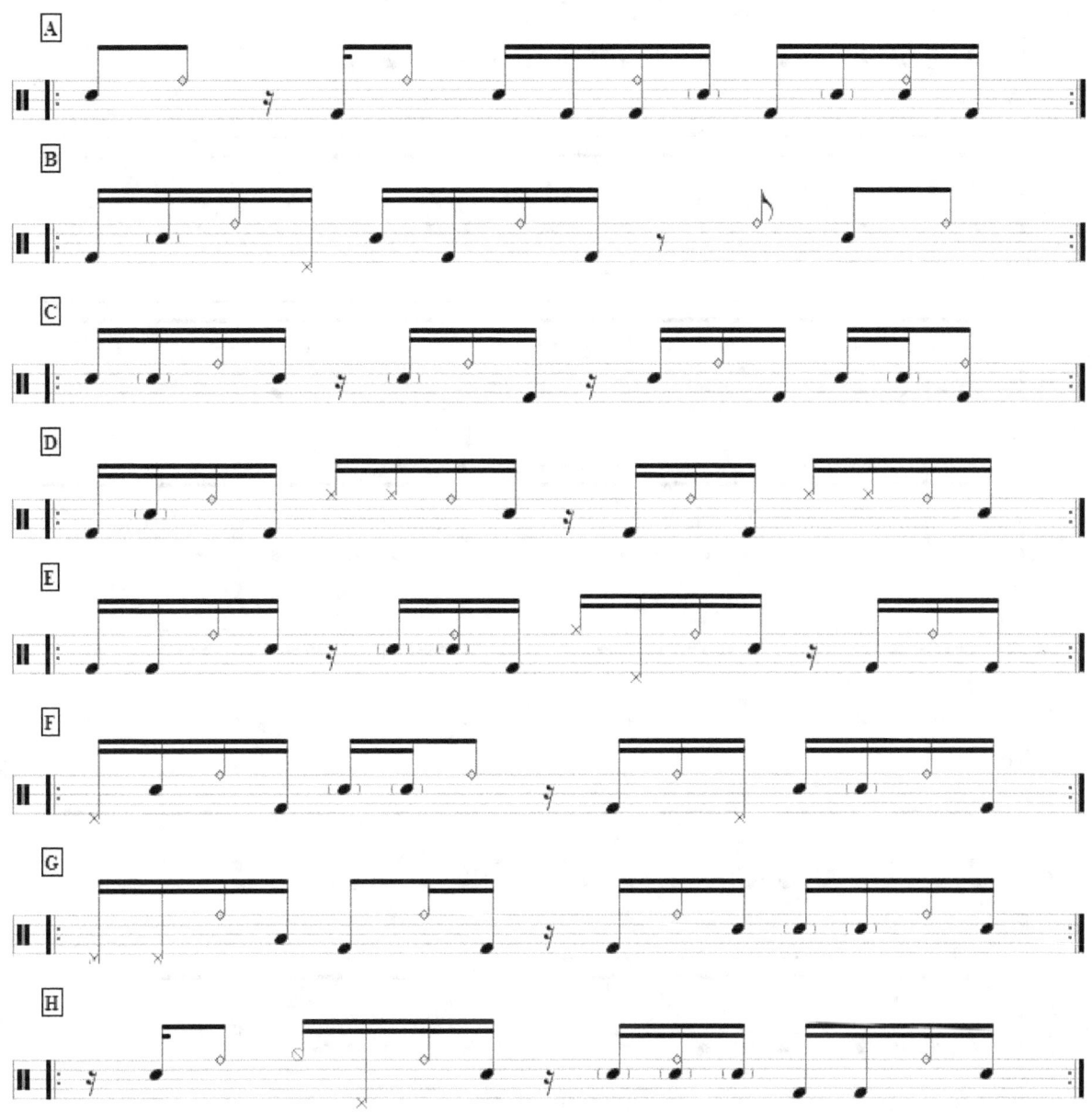

Triple Feel Hi-Hat Off-Beat Exercises

Here are some examples a transformed from the **Thomas Lang** book about "Advanced Coordination and Foot Technique" into *Hi-Hat Off-Beat Patterns* in triplet feel.

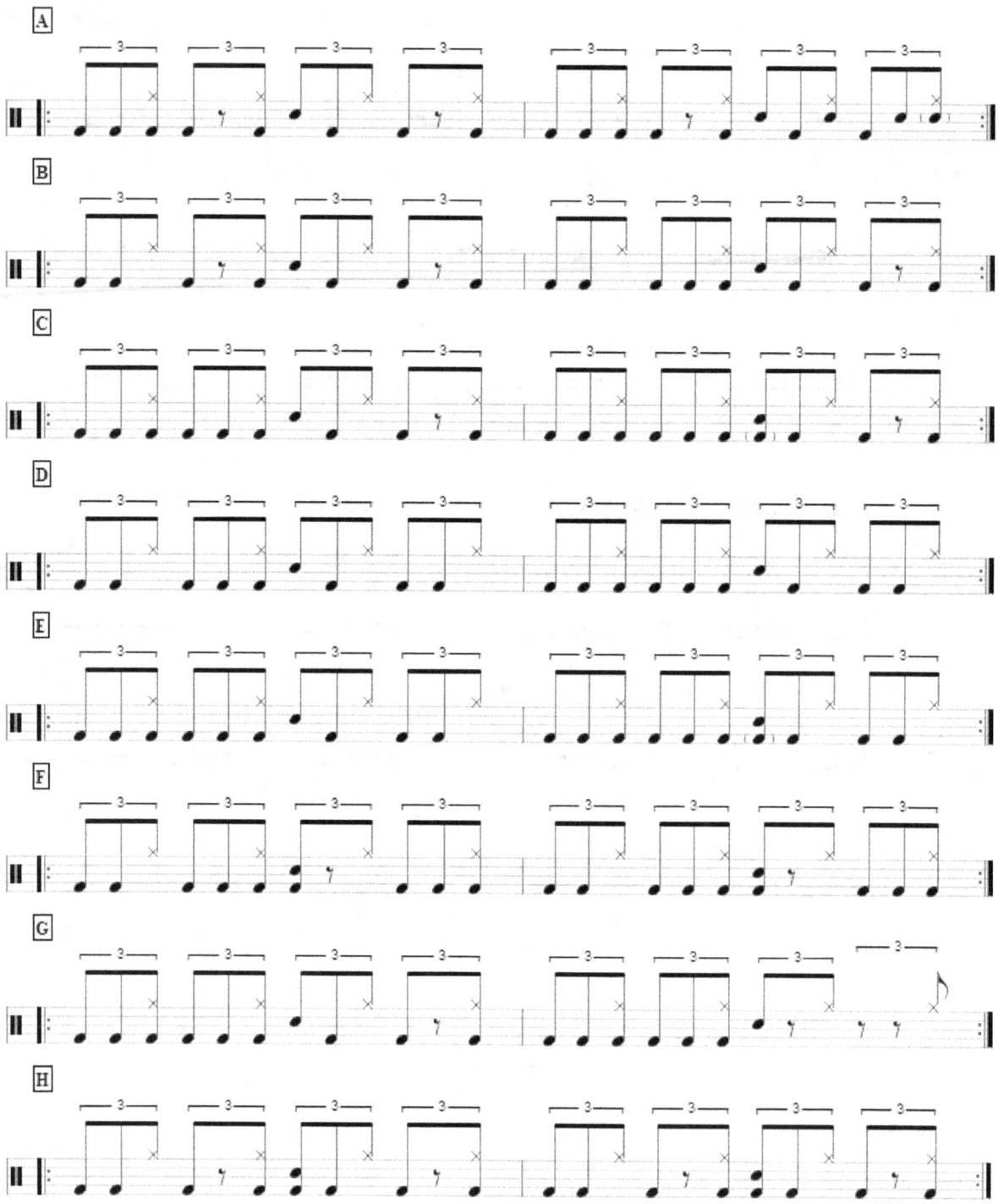

Hi-Hat Permutation Patterns

If you really want to get used to *Permutation* in its whole meaning, I recommend "Future Sounds" from **David Garibaldi**, that's where I learned most off all how grooves can be permutated. The following patterns are just a tiny example of how you can use it in your drum arsenal.

The whole purpose of permutation, is that some parts of the grooves moves across it, while the other parts just keep going, this creates a "moving" effect.

Hi-Hat 3-Note Permutation

All these patterns where written with the standard triplet feel on the Hi-Hat. Here are some variations you can use to extend the exercise. It's still the same triplet but in a different structure. Because all the rest is eliminated, you can see the pattern is moved across the bars. Please try also to create another version to permutate.

"Don't think inside the box, think of no box at all"

You can use these systems to make the exercises more interesting. The next page is written

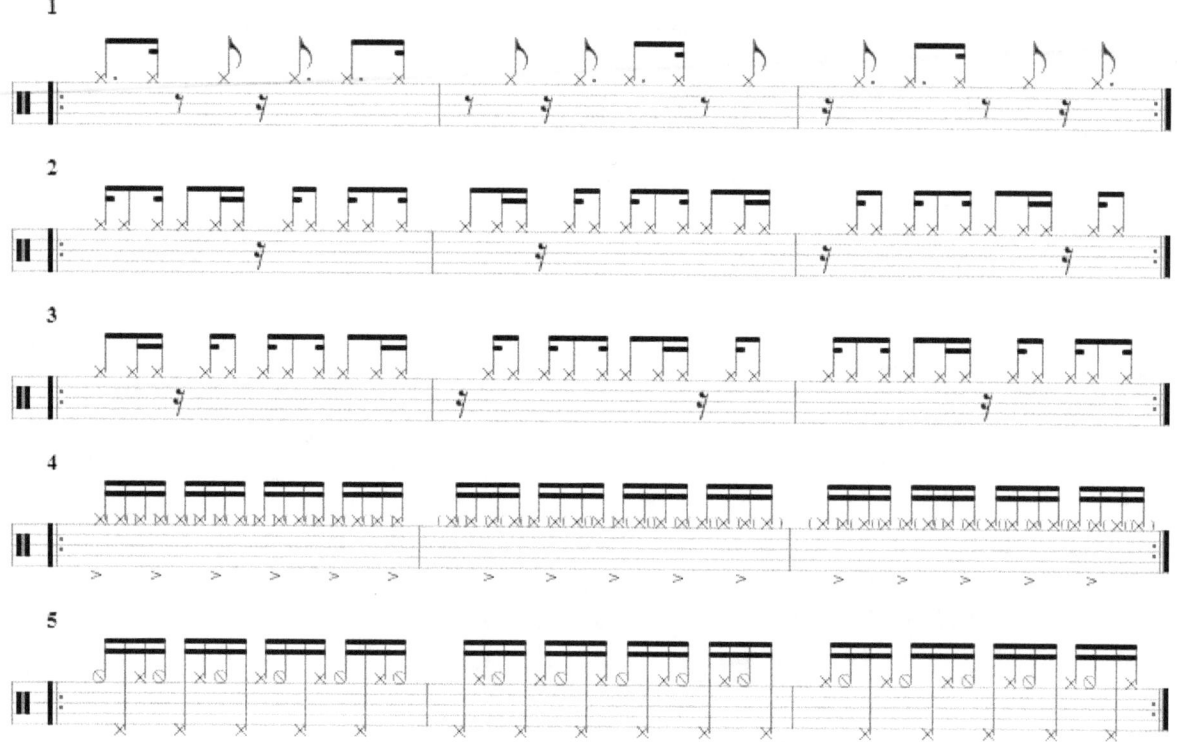

with the first system (1) but you can experiment with others as well.

So together you have **40 exercises** with these systems. If that isn't enough you can play each exercise with your other hand (not leading hand) to double 40 to 80.

Have fun!

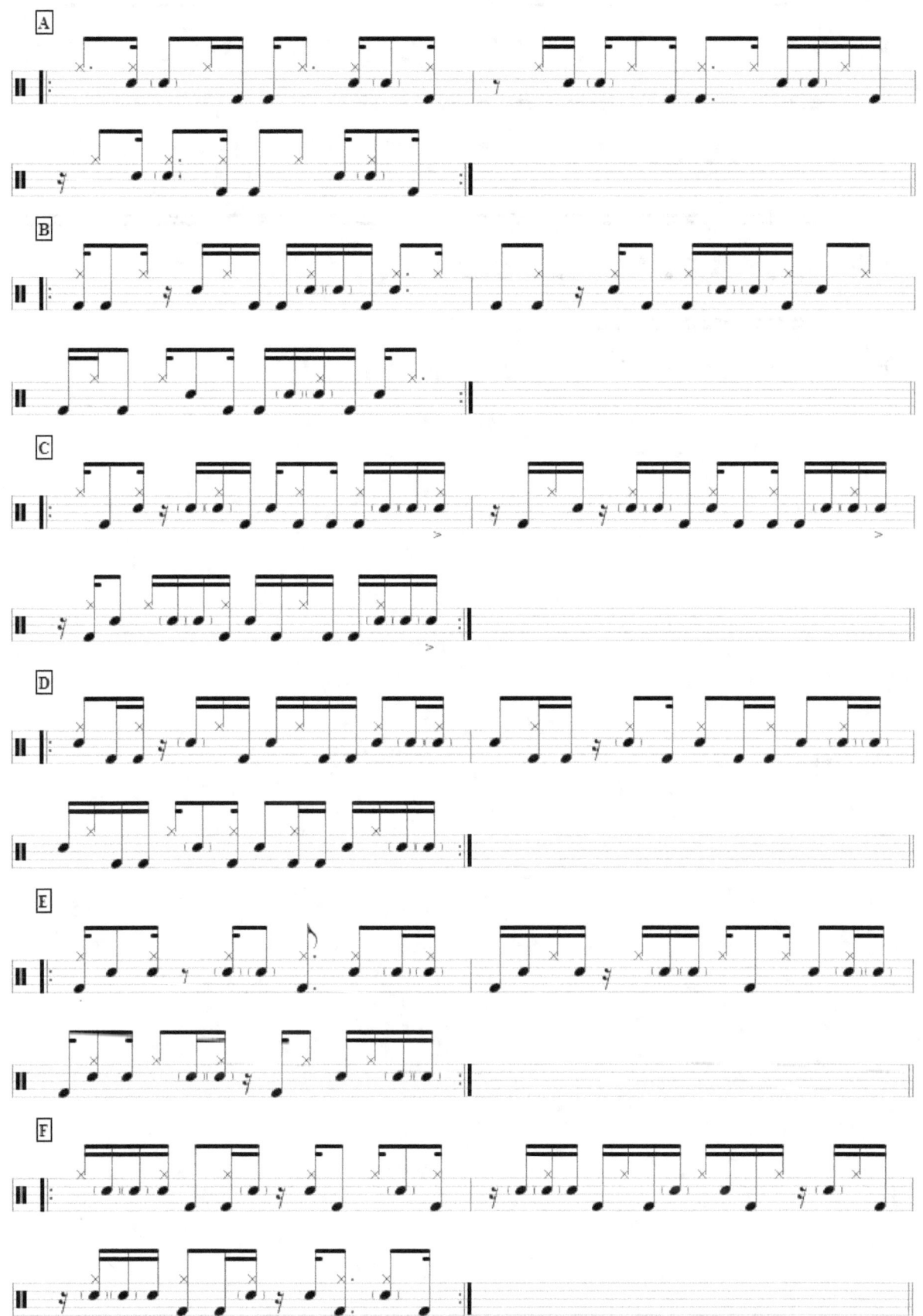

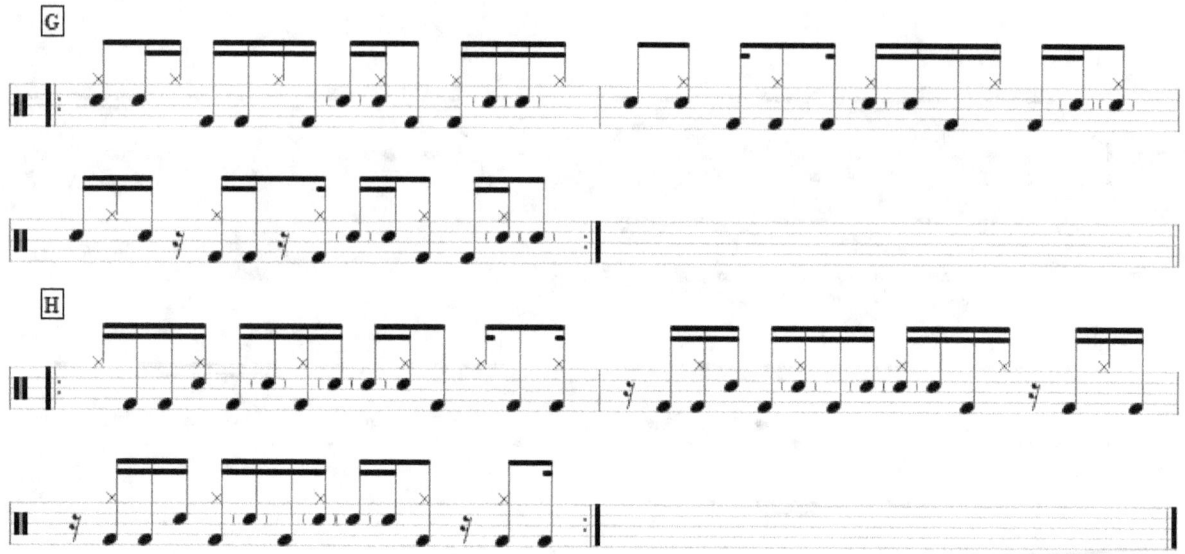

Hi-Hat 5-Note Permutation

The second part is a 5-note permutation with the Hi-Hat; this means that we must play the groove 5 times before we're back in sync. Because we'll have to play it more times than the previous exercise (3-note permutation) it's a bit harder to understand and feel the place that the hi-hat pattern and the snare/bass drum pattern are back together.

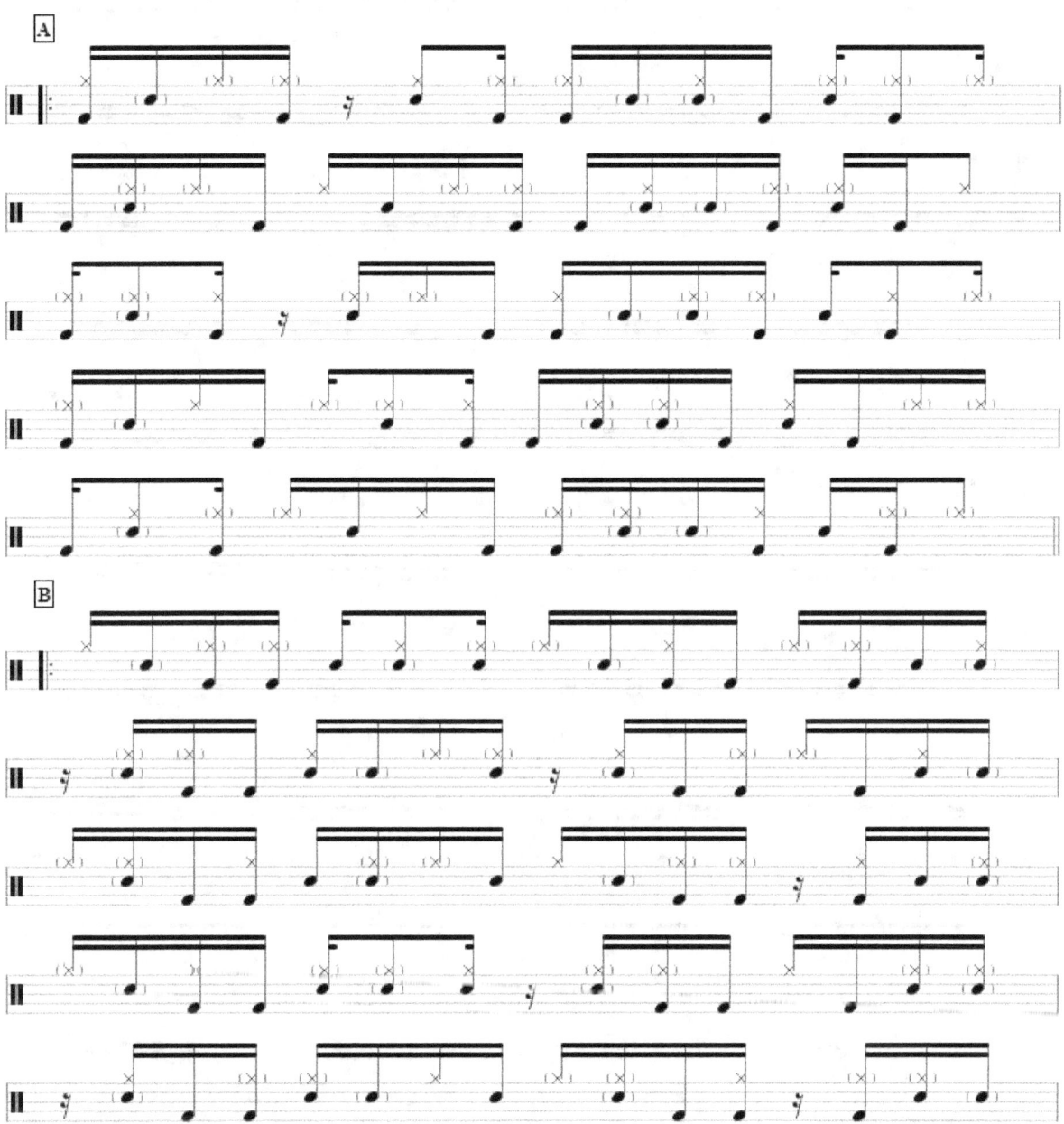

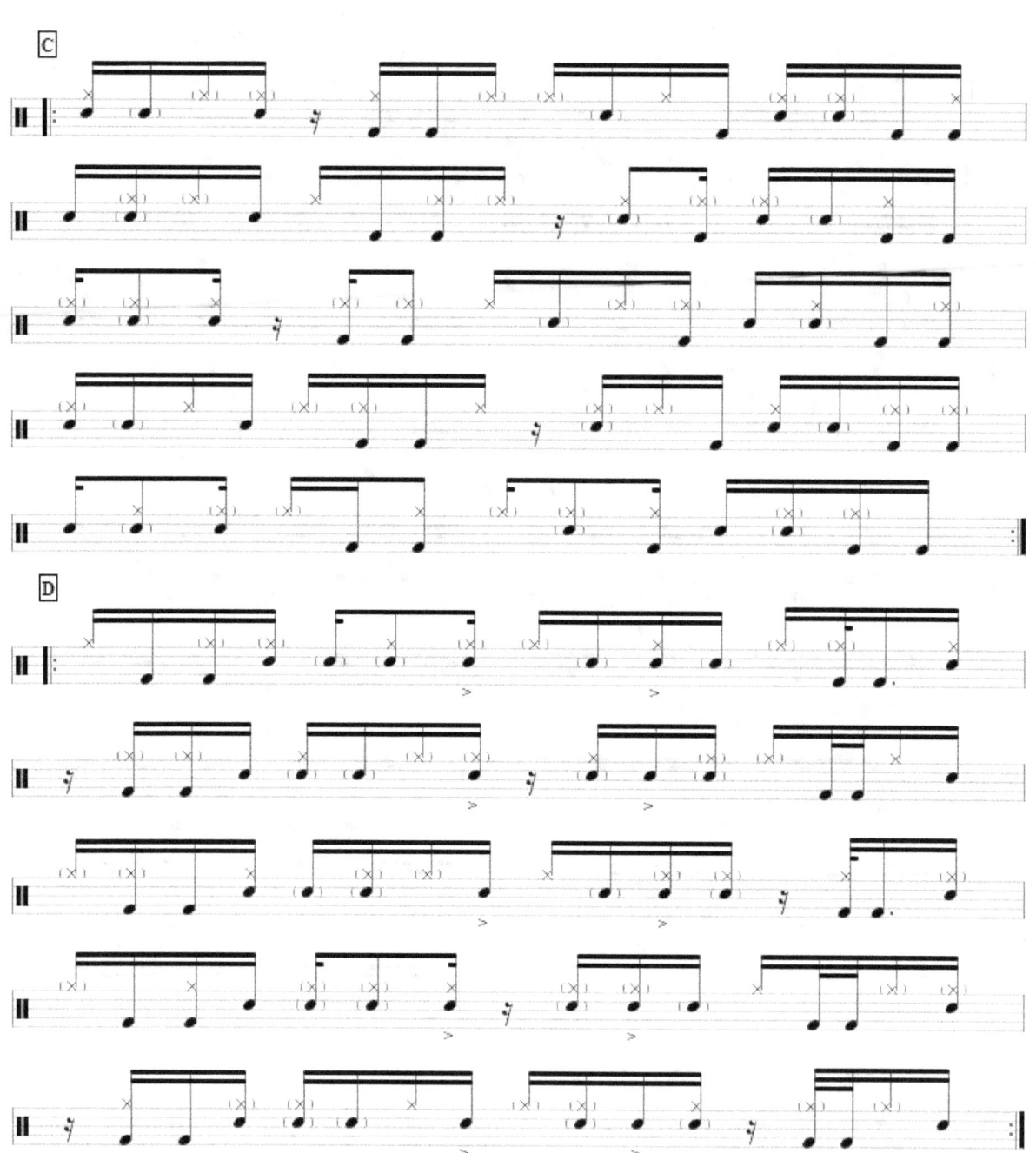

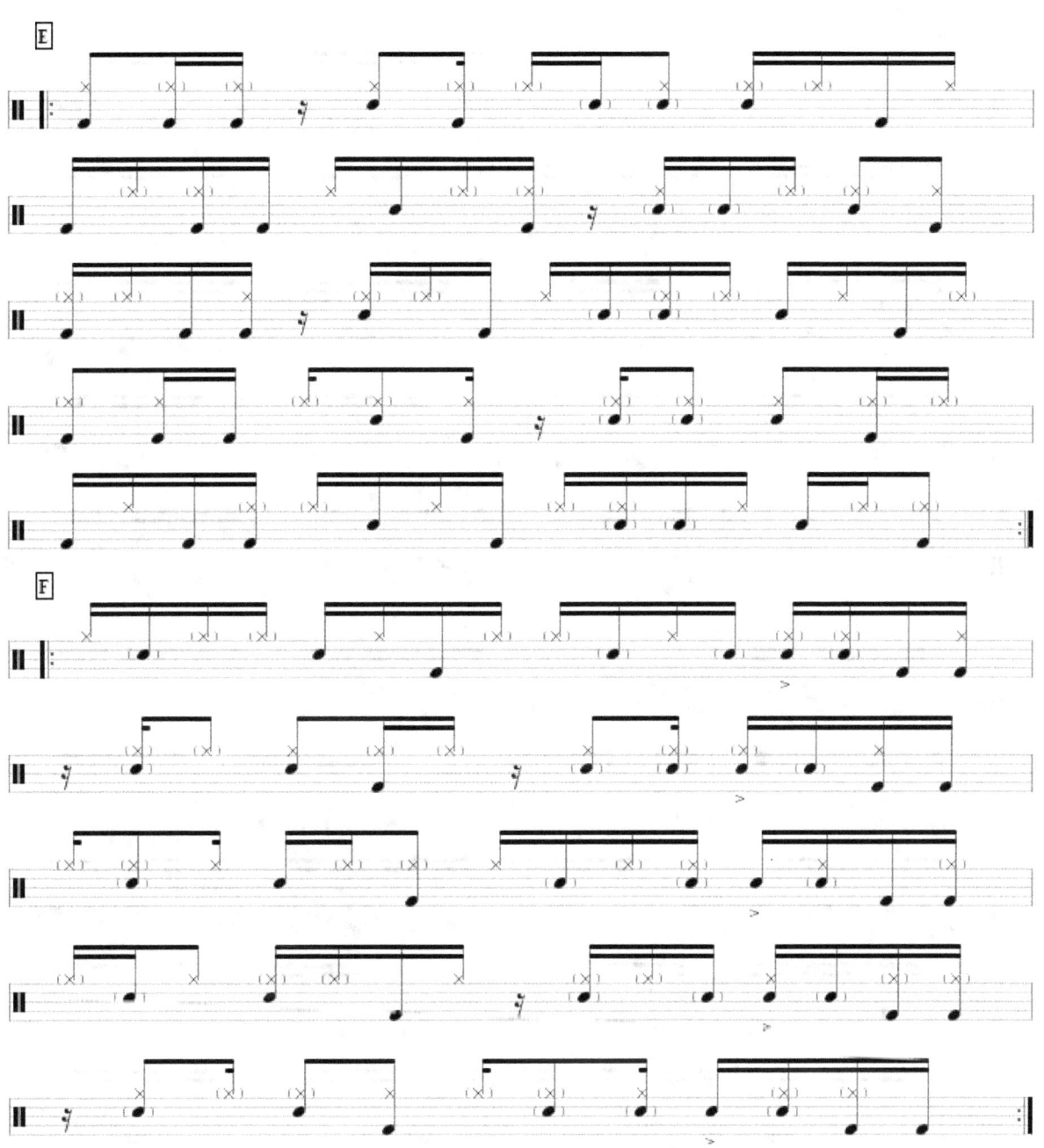

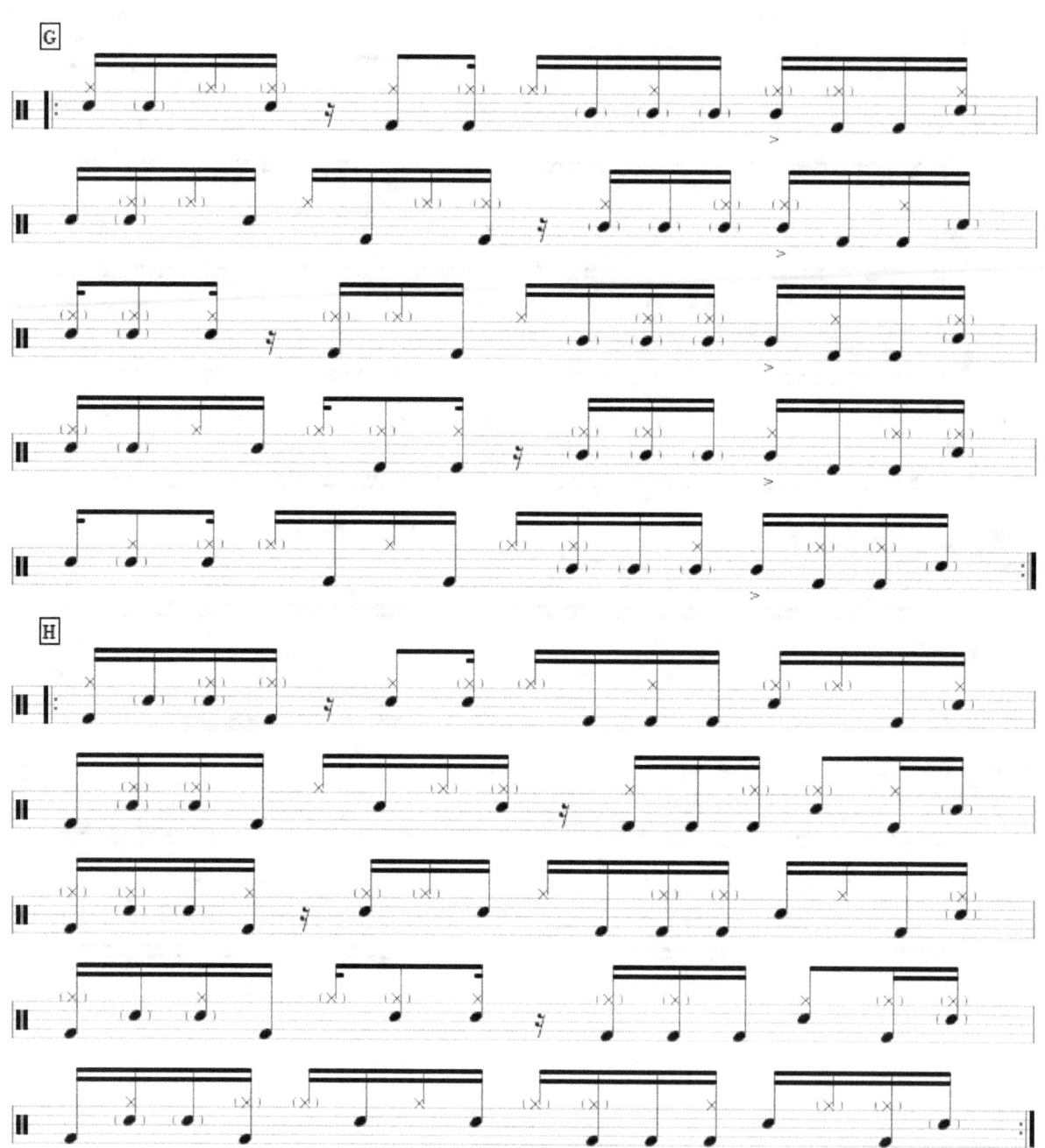

Hi-Hat Supported Patterns

Just like ghost notes can support the accent, so can the hi-hat supports the whole groove. Some might say that this sounds more like an interaction-kind-of-pattern. The main difference is that the hi-hat is part of the pattern while here it's supporting the pattern.

The hi-hat adds that extra layer to your groove that really helps the groove to another level.

Following hi-hat pieces can be combined with the grooves described later:

Hit-Hat Basic Supported Patterns

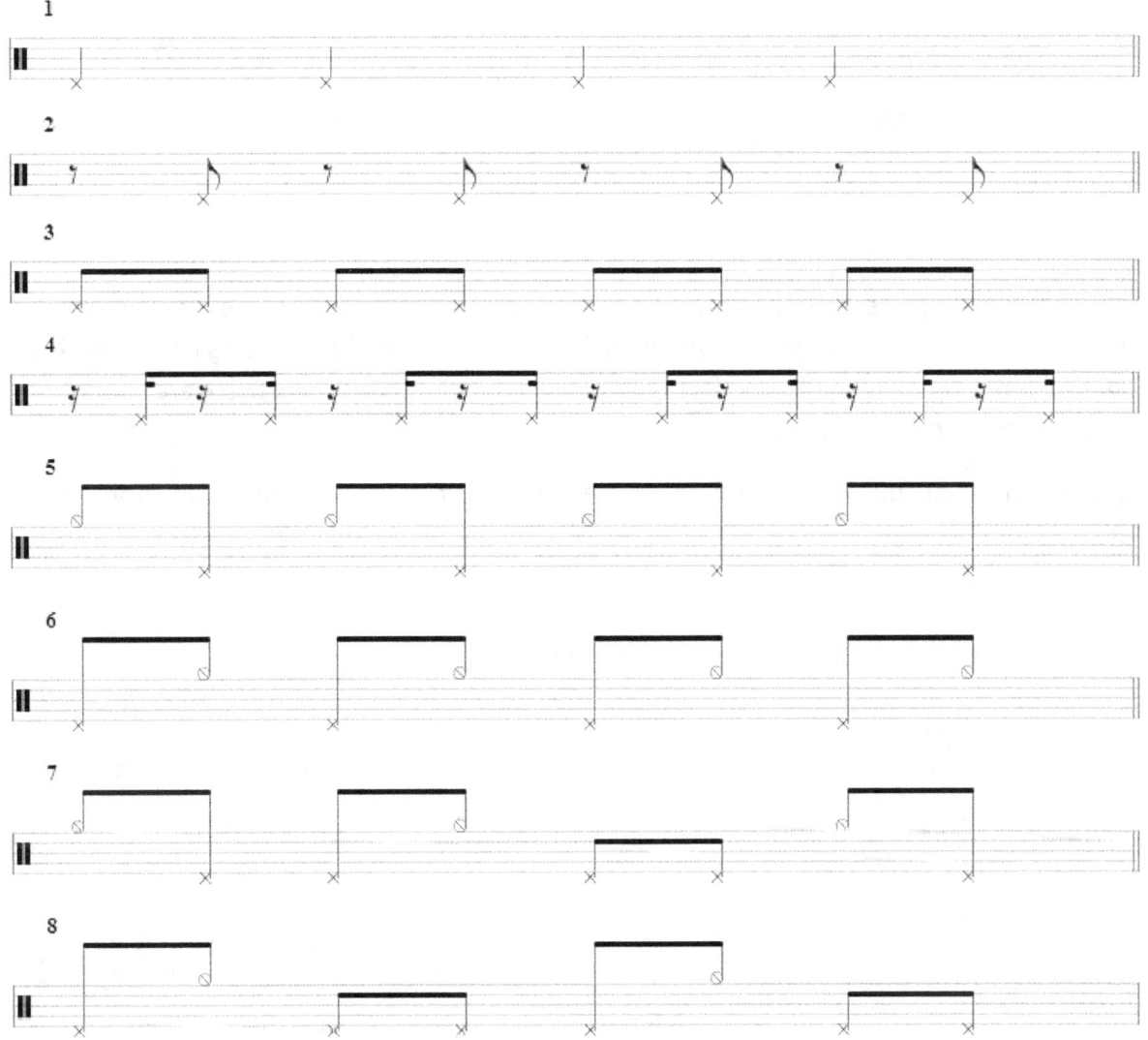

Hi-Hat Advanced Supported Patterns

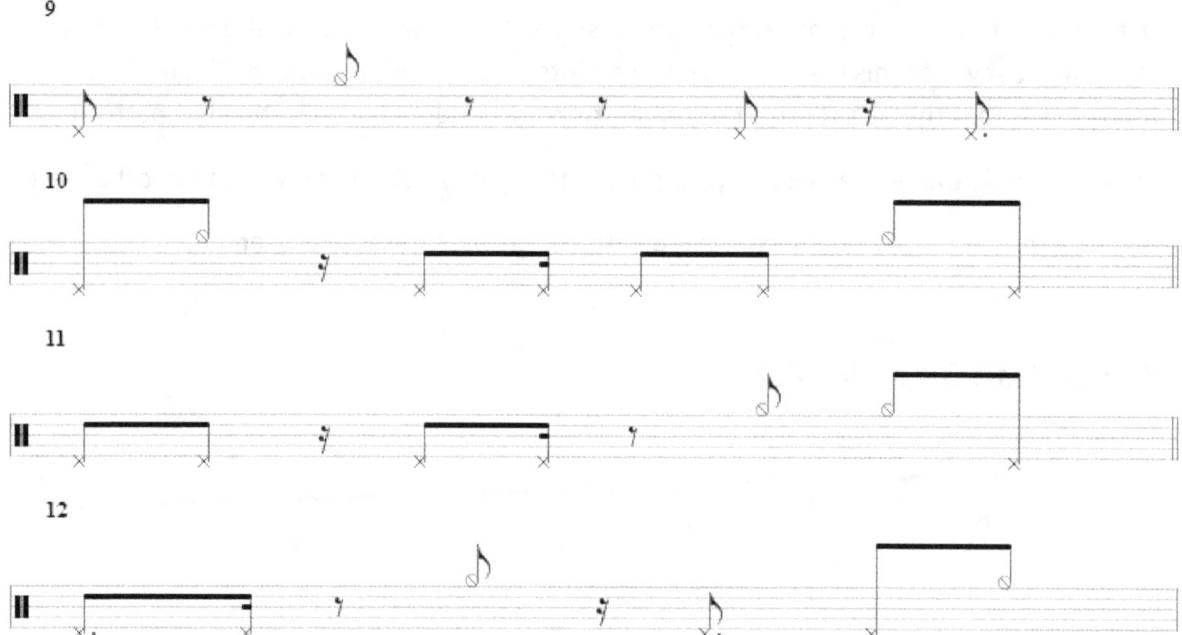

Now you got 12 patterns with the hi-hat, we can combine them with some grooves. Notice that these 12 patterns are played with your foot, also the open hi-hats. This can be done by kind-of jump your heel on the pedal board of your hi-hat pedal. I think there are a lot of lessons about this technique.

We use this technique because now we have our hands clear to play some cool grooves on top of them.

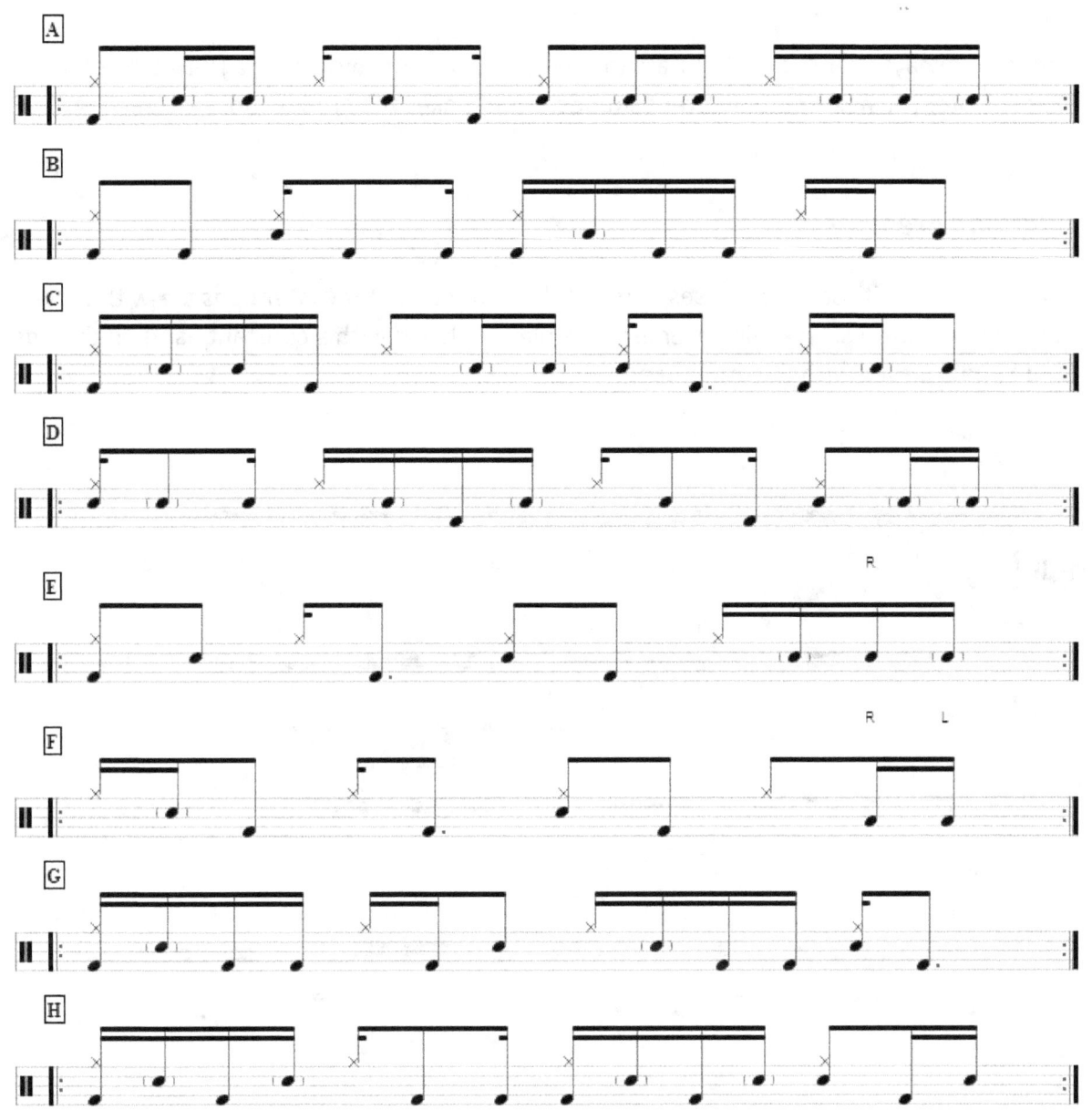

Hi-Hat Interaction Patterns

I found it always useful to add Hi-Hats to other rhythms. Just by adding a Hi-Hat instead of a Ghost-Note; you hear more different sounds, what makes the groove more interesting.

Warmup Exercises

First let's start with some exercises that will show more what my intentions are with these interaction patterns. Following exercises are played always with a constant hand on the ride and hi-hats played with the other hand.

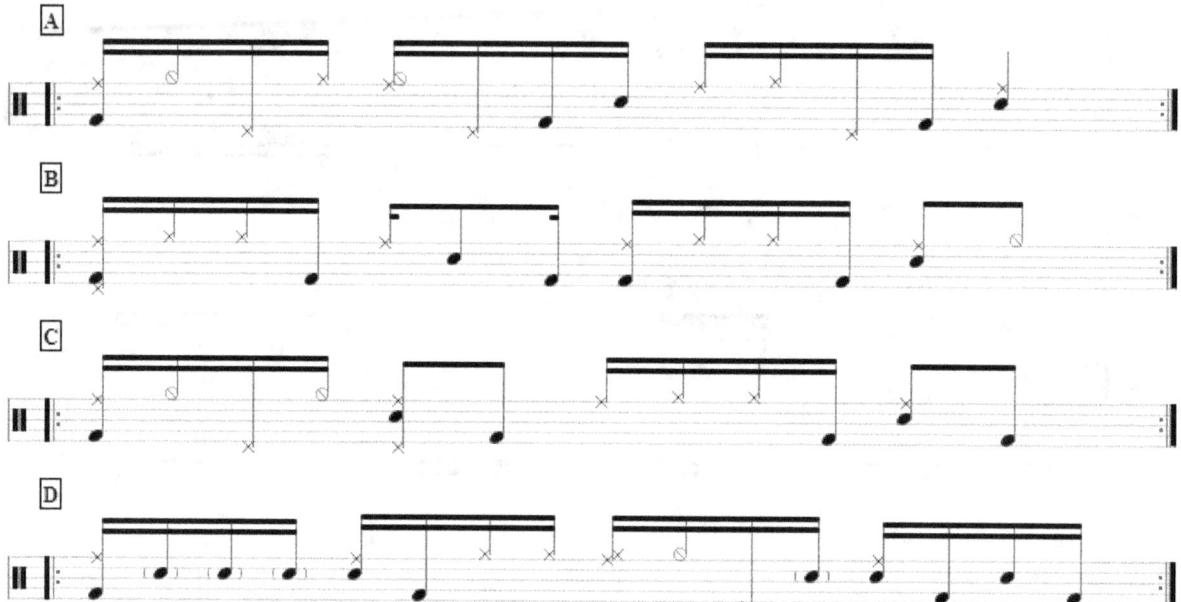

Advanced Exercises

These exercises are less played in a fixed rhythm or a constant hand playing. Some are played in 7/8 but it wasn't my first intention. I just discovered it when I write out the exercises that I was playing.

Personally, I think that the hi-hat is a perfect element to use in an odd time signature interaction pattern because of the short notes it produces.

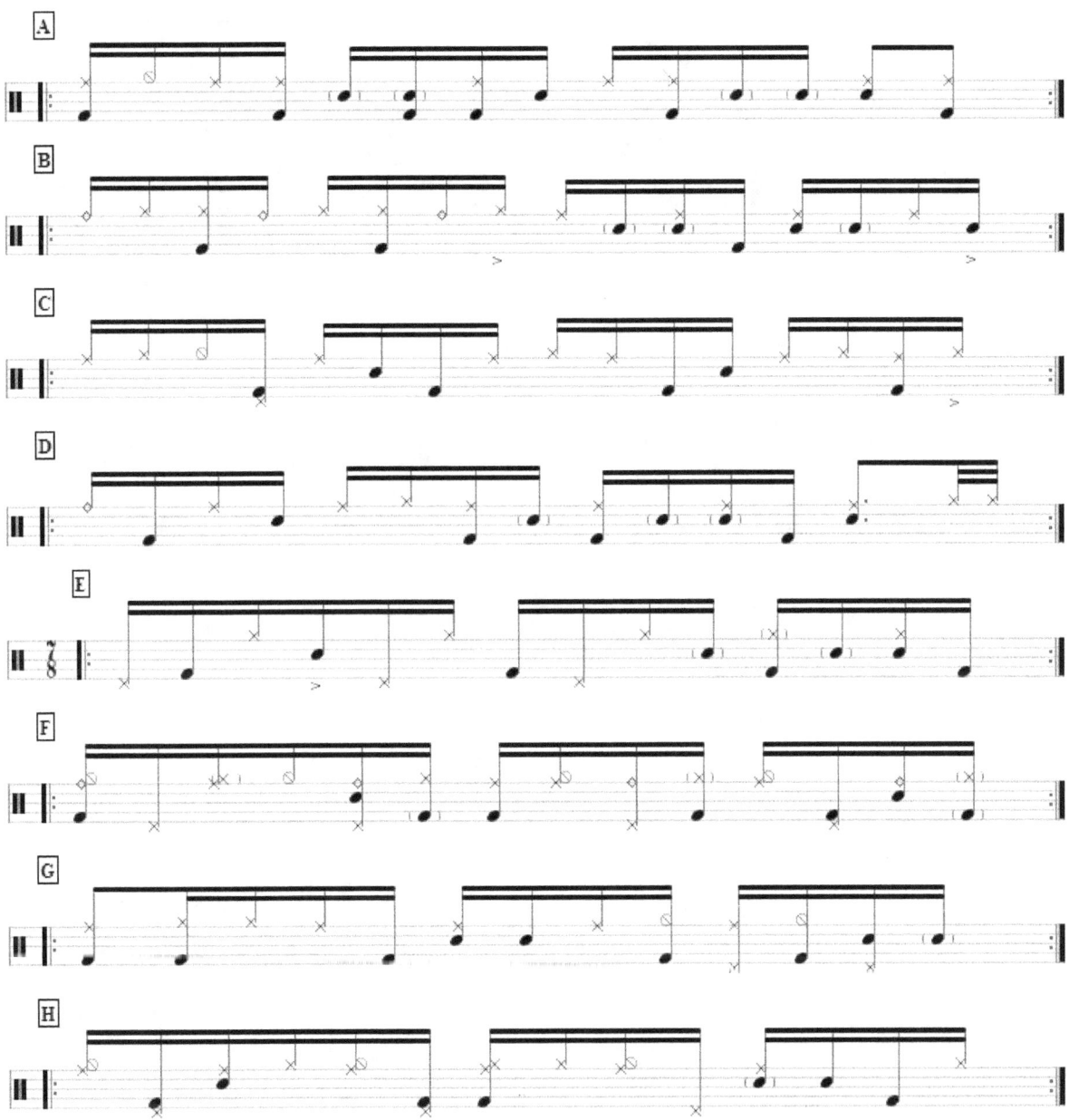

Linear Structure Patterns

The first couple of patterns I learned in the **Funk** genre were **Linear Patterns**. So again, funk is really an inspiration for me to write progressive music and Djent.

For the folks who don't know what linear patterns mean: linear patterns are drum grooves for which each note in the bar stands alone and is not played together with other notes.

Standard Linear Patterns

Let's start with some standard patterns played in a linear structure.

Examples

First let's give you some examples and practices to feel more comfortable with linear patterns. Again, we can use some rudiments to introduce this concept.

There are a lot of books around this topic so please don't consider this the full-introduction, this is just to let you introduce with some practices.

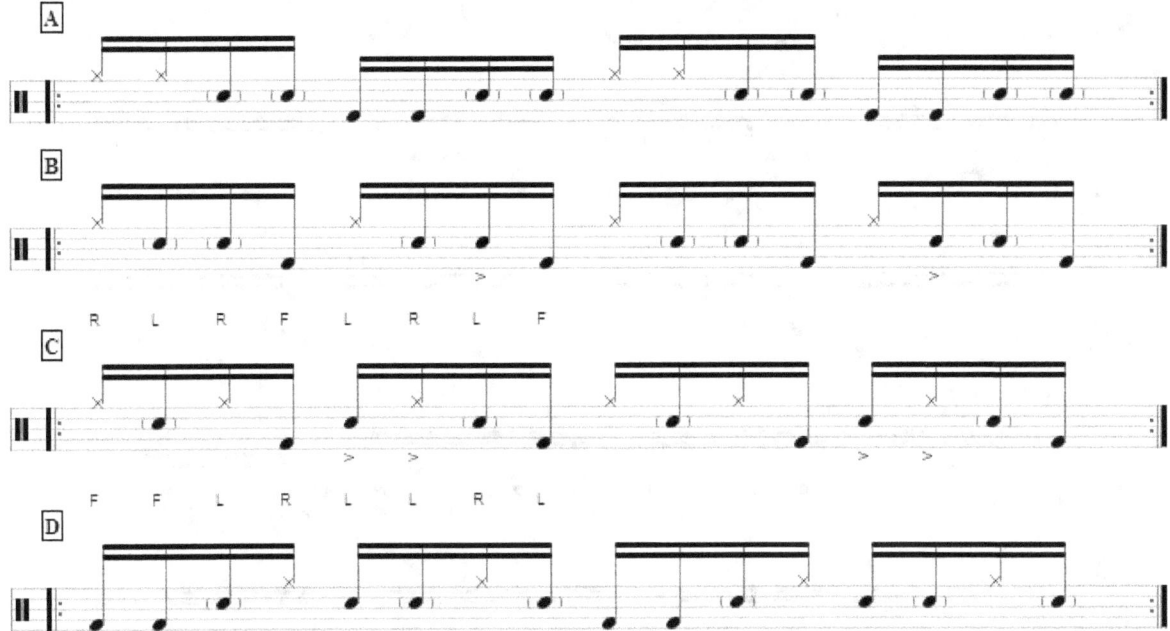

Exercises

Following examples are based on funk grooves but please use them wherever you see fit.

Notice that the Hi-Hat is never played open on these so you must close it fast if the next note is played with your hand on the Hi-Hat. Ghost notes on the Hi-Hat are played with the tip of your stick while the accents are played with the stick's body.

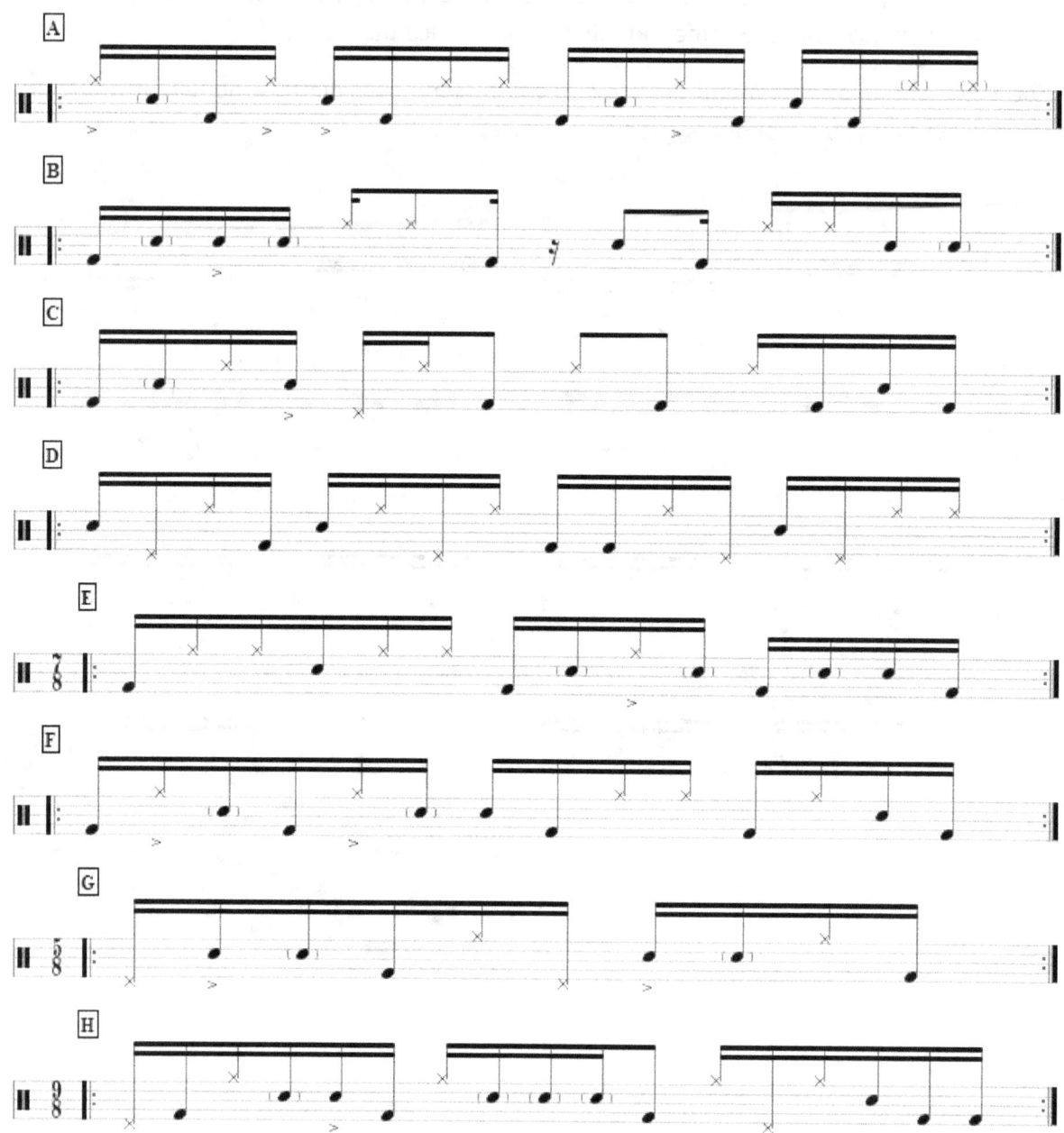

Broken Linear Patterns

I don't know if the correct name for these patterns are "broken" linear patterns. It's just the name I give it to these practices. The practices have some gaps in them that makes the groove more open.

The **G** practice doesn't have any gaps explicitly but rather has some long ghost note hi-hats that makes the groove pauses for a while. This simulates the "gap".

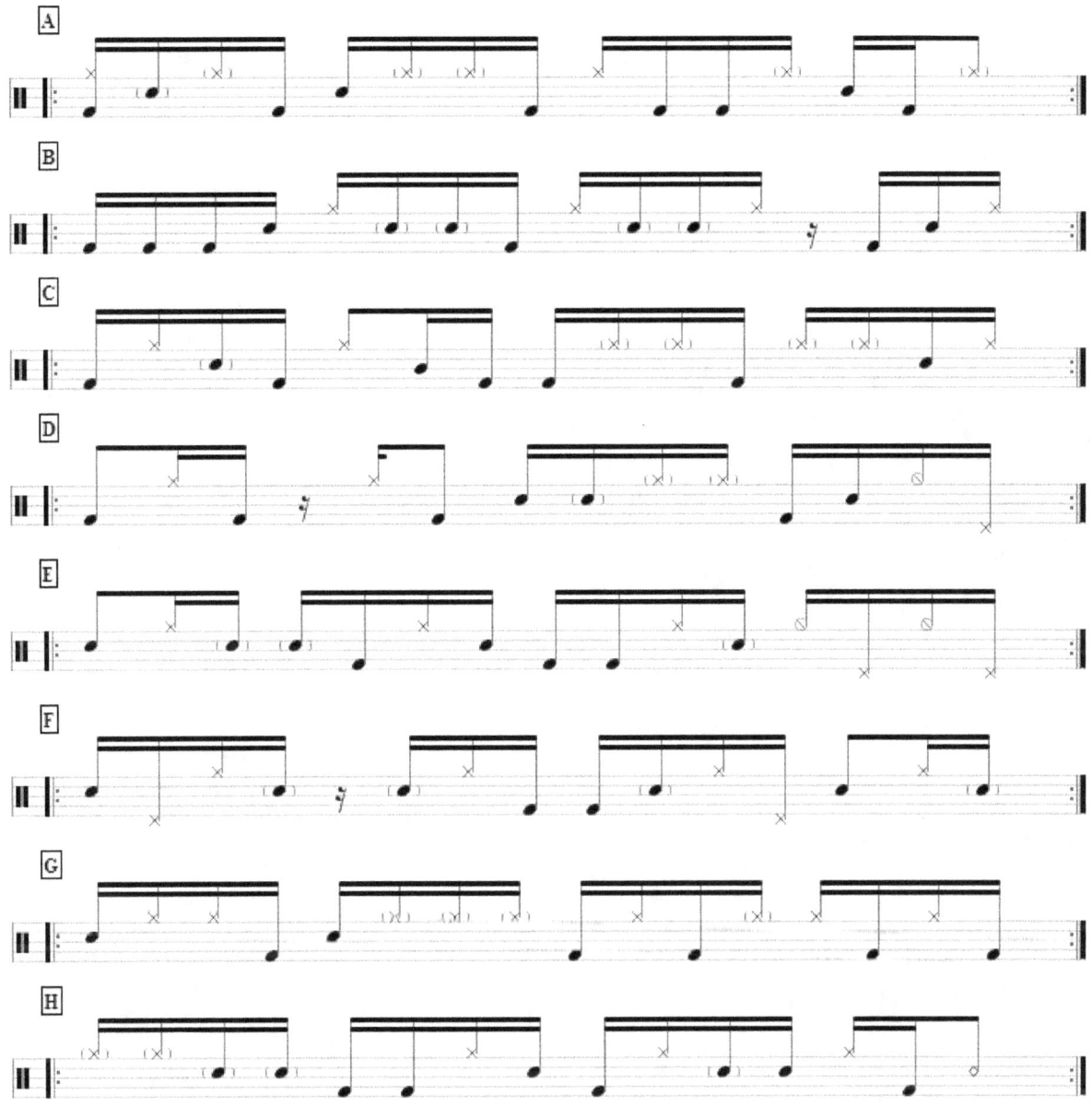

Tom Patterns

What struck me is that a lot of practices in Djent are played with toms embedded. I don't use this so much and am still practicing this technique, but nonetheless I wanted to include some ideas.

If we include too many toms in our grooves, we have a bloated groove that feels more like a fill than a groove. The trick is to not include too much.

Tom Interaction Patterns

Following patterns include some toms that interact with the groove. Tricky at first, but a nice intro into the practices with the toms included into the groove.

The first time I encounter such a way of playing, it was reading about *Funk Drumming*; and in practice: listening to Djent music. In musical situations, grooves that interact with toms are sometimes played within the *Break* part, or maybe a *Build*. See the transcriptions at the end of the book for some examples.

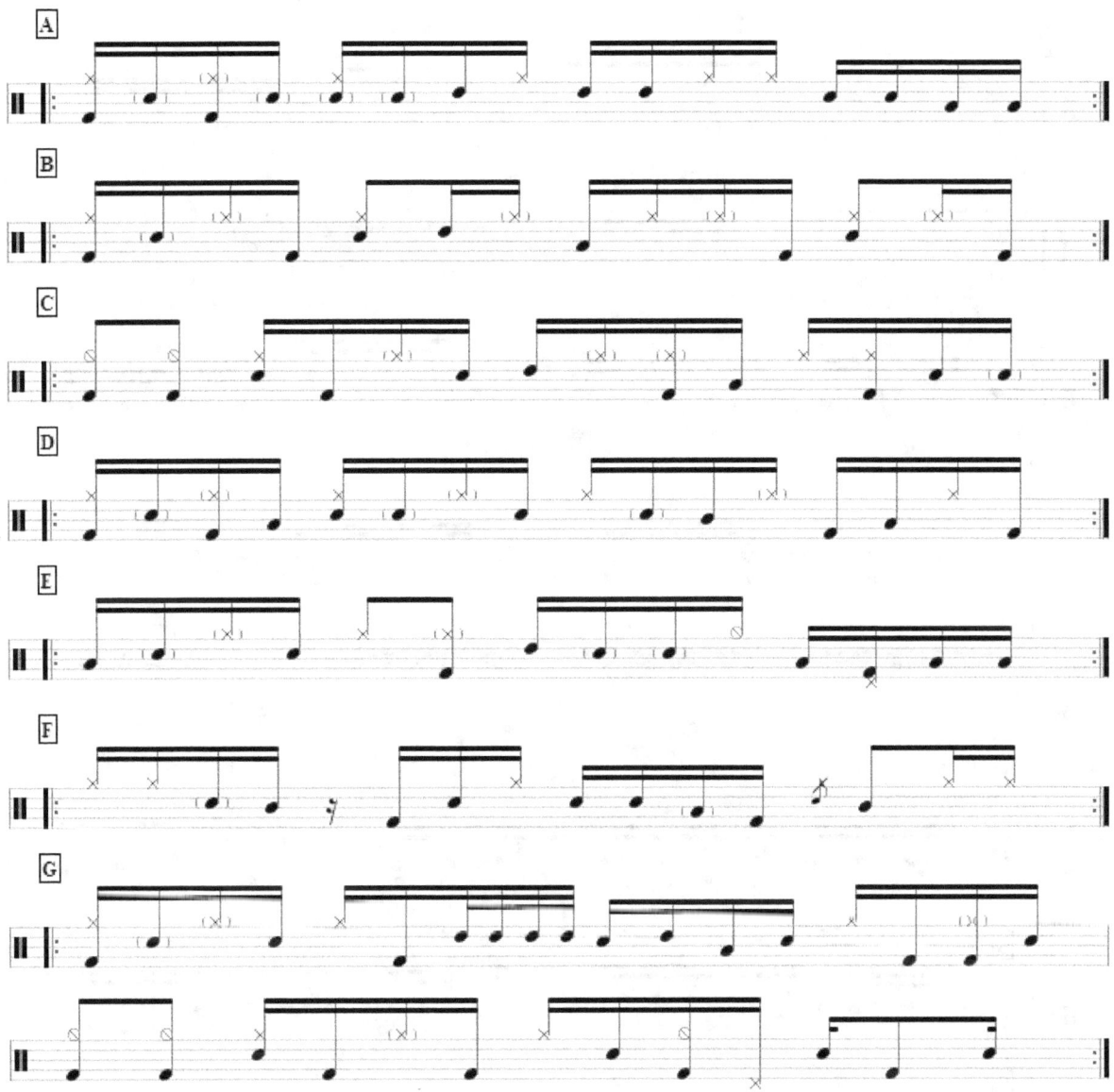

Files

No, I'm not the best in writing files. In fact, I find this one of the hardest parts. A file must be catchy, added-value, fun to play, …

When you play a file, this should a part of the groove and not just "because I can play a file". That's why I find it so hard: there's so much going on.

Following exercises are some I came across during my playing. Don't forget the transcriptions at the end where you can find files within the songs.

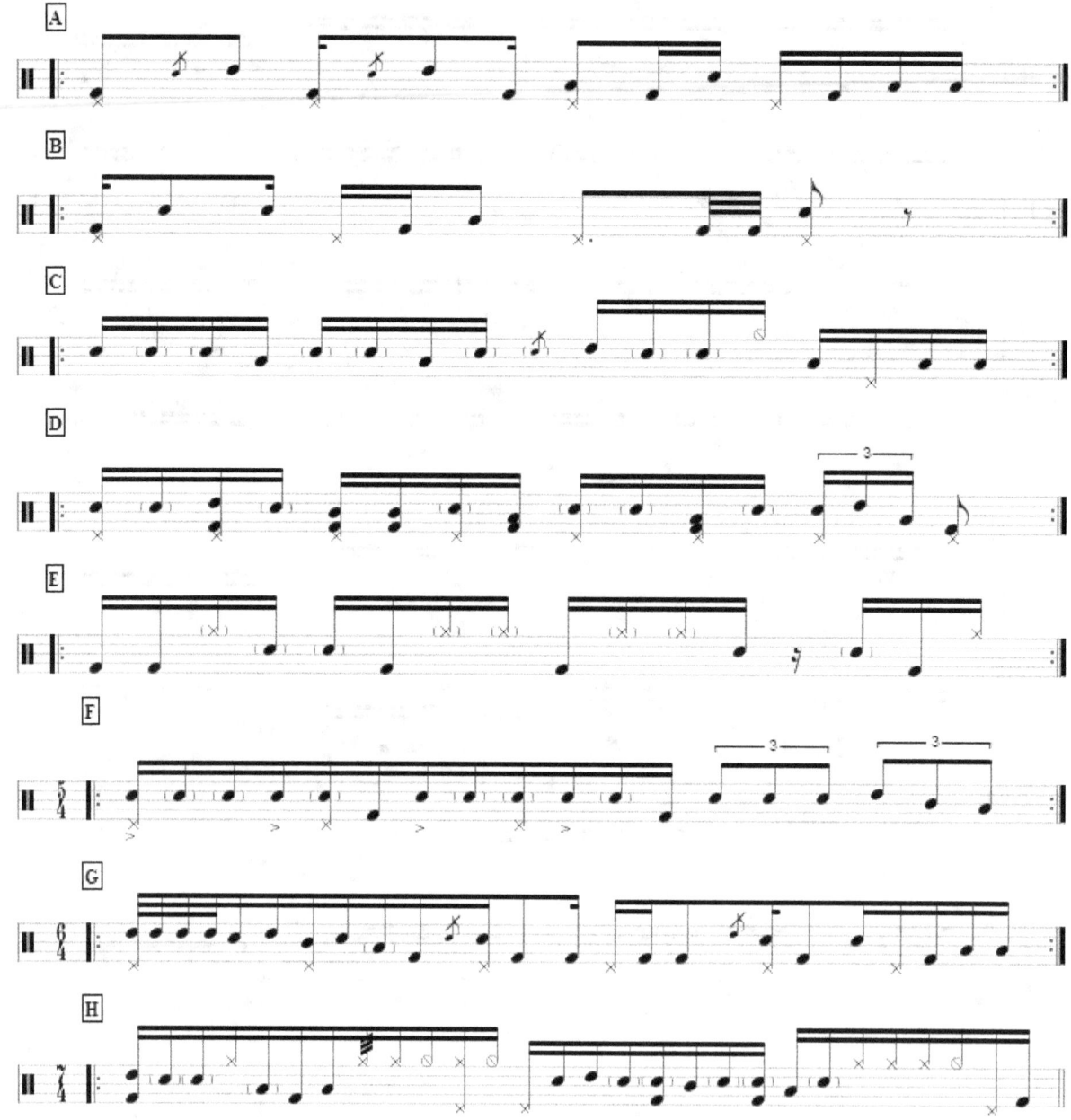

Odd Signatures

You already see many exercises with odd signatures in them. I tried to give you some odd-signatures while practicing other techniques. By combining two techniques, you learn quicker and use your time efficiently.

Some people think that Djent is all about the "odd-signatures", but not all Djent songs have odd-signatures in them and not all not-Djent songs are played in a 4/4 signature.

What do I mean with odd signatures? 5/4, 7/8, 15/16, … anything "out-of-place". That feeling when you can't nod your head at the music. That moment when even non-musical people discover that something is going on.

In my opinion, there are two different ways to write odd-signature grooves. The first way is to write explicitly in that signature. This could be done by starting from a 4/4 groove and just add or remove some parts till you have your odd-signature.

Or the second way is to write from pure feeling or improvisation. These grooves are most likely grooves that don't sound directly like odd-signatures. They "hide" their time signature.

This isn't the case with the first way where you explicitly feel that odd-time frame.

Explicitly Odd-Signatures

The first way is the simplest way to show you some odd-signature-writing. Let's start with this groove:

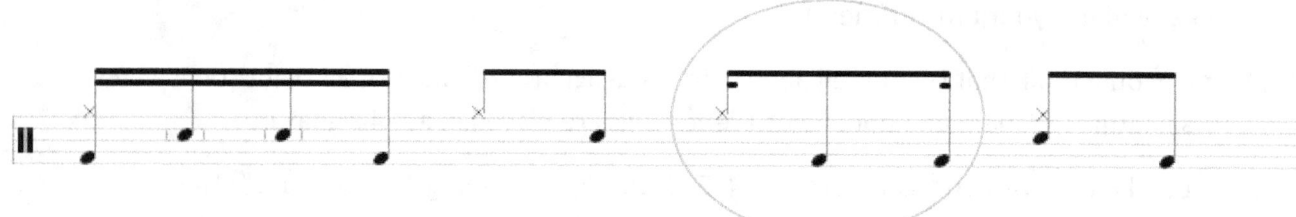

Now, we have a "simple" 4/4 groove. Let's repeat the third part. By adding an extra part we're entering the "odd-signature" world. Now we have a 5/4 groove:

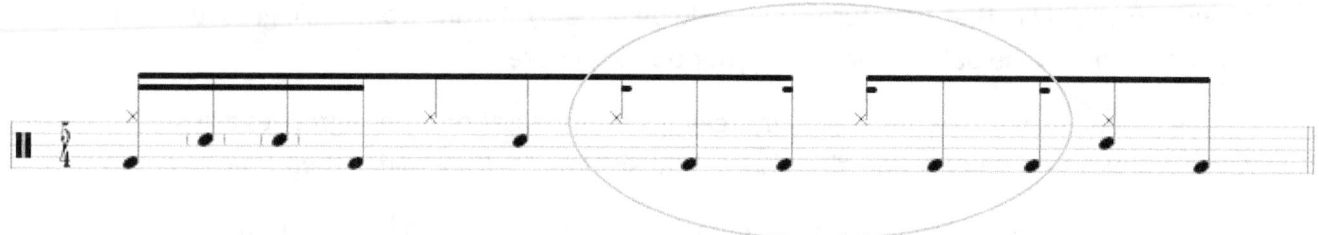

Or, we can remove the part entirely, this way we have a 3/4 groove:

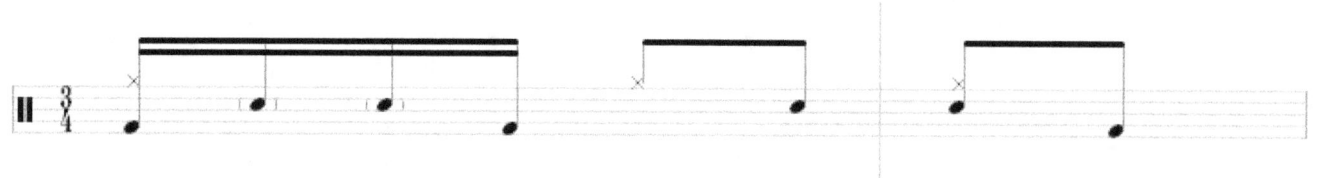

I hope you see now how "simple" it is to enter the "odd-signature" world. Sometimes this way helps me to write or combine two pieces that in the first place don't match.

But be careful. When you change the internal structure of the groove, it can quickly become forced and you could lose the intention or the feeling the groove was taking when it sounded in its original version.

Remember, try to make a song.

Implicit Odd-Signatures

Writing implicit odd-signatures are a bit more difficult because these grooves sound like their supposed to instead of explicit. If you change these grooves to a "normal" 4/4 signature, it sounds forced.

So, it's just the way around.

Let's look at the next groove, notice that the groove in some way splits in two parts:

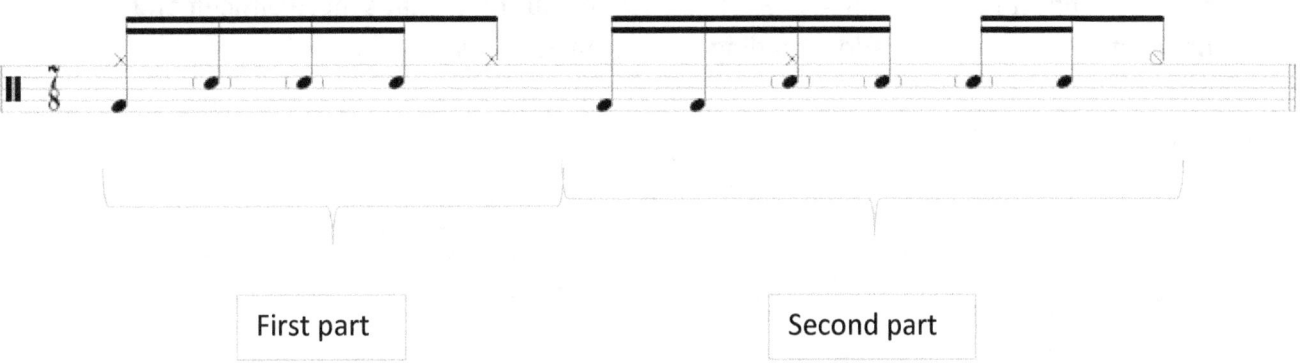

Notice that the accent on the snare goes over in the hi-hat and an open hi-hat in the second part.

Writing implicit odd-signatures are taking another approach because now we must start from the signature itself instead of going towards it.

Try to find later in the transcriptions the explicit and the implicit odd-signatures and try to experiment with them yourself.

Bass Drum Patterns

There are of course many fun patterns that are bass drum related. I personally find this not the most important part of this genre. I think that other items are more interesting. Though, it's still important to have some skills with your feet.

The following sections are about the "decoration" or "leading" you can add with your feet. I will not talk about fast double bass drums or anything like that. I think that everyone can play fast if he/she wants it; it's the technique that's difficult.

Do try some ghost notes, accents or even flams with your feet. That's more difficult and more useful to create Decoration/Leading Bass Drum Patterns.

Leading Bass Drum

These exercises introduce bass drum notes as leading notes of the groove. This means that your feet are the dominant part for these grooves.

Try to give them some room by playing the multiple ghost notes on the snare a lot softer than you usually do.

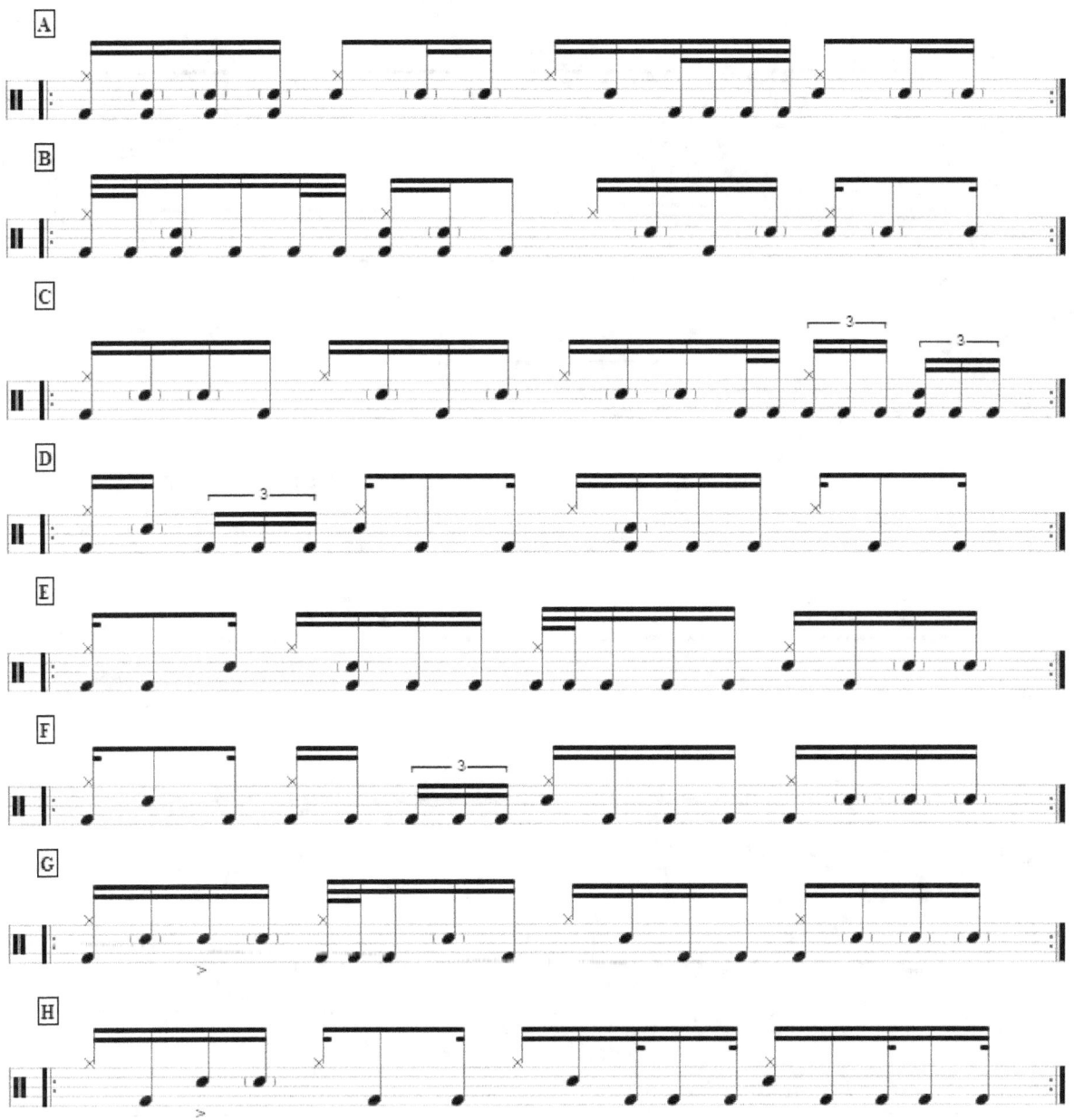

Decorated Bass Drum

By "decorated" I mean, "not dominant" or "not leading". Decorated notes can be ghost notes for example – notes played in the background but not the main act. Following exercises are decorated bass drum notes, which means that the bass drum doesn't play the main act of the groove. Although these notes aren't played as ghost notes.

I think you could say that the snare and bass drum are both taking the lead on these

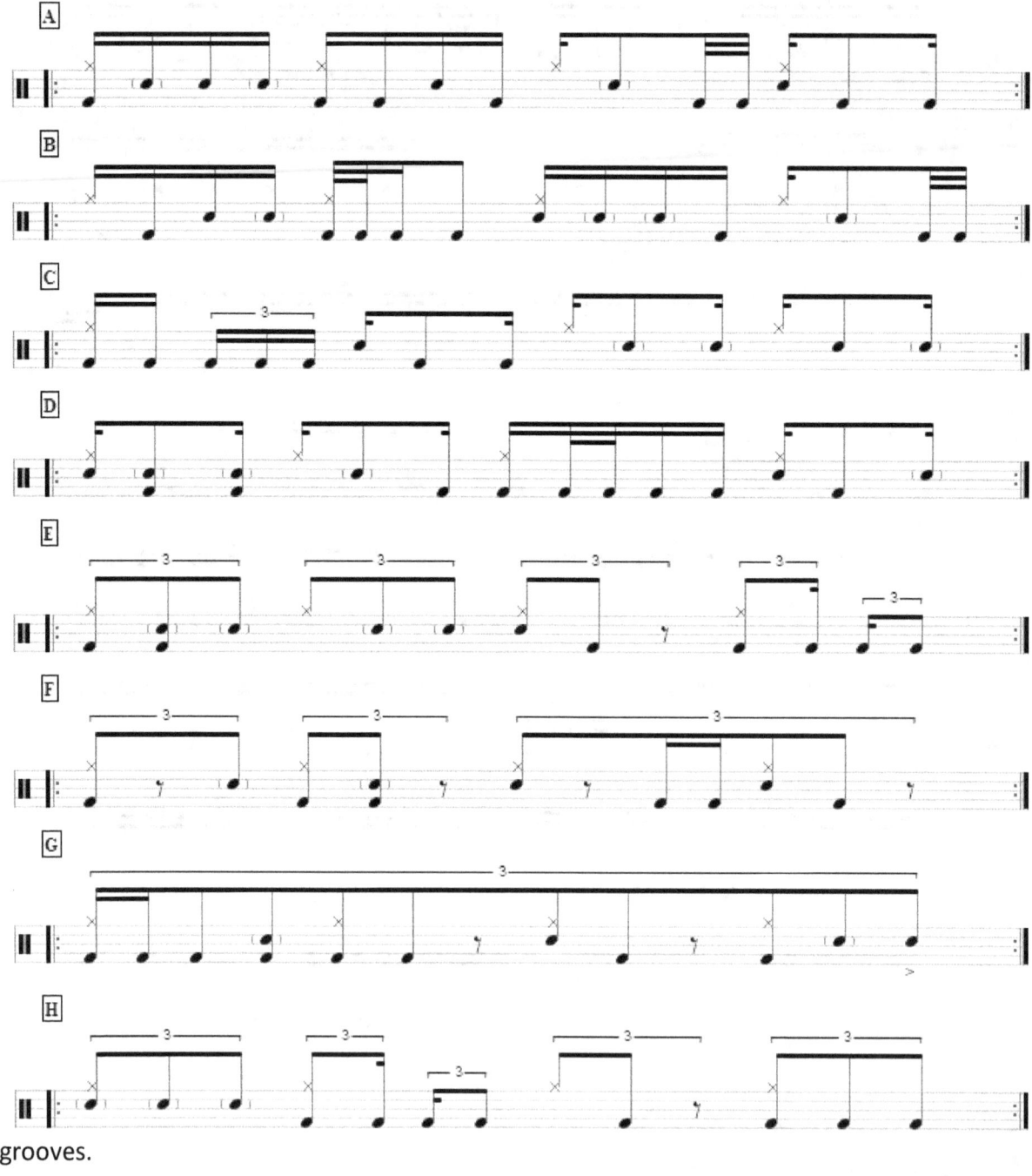

grooves.

Music Structure Patterns

When writing music there're different building blocks you can use: **choruses, verses, solos, intros, outros**.... The combination of these blocks is not always enough to create a song, and in the Progressive/Djent genre this is even more the case.

That's why I find it useful to have some extra structures to work with in the process of writing those songs. It helps me to keep a high-level view about the song, certainly if the song increases the 10-15 min length. In an improvisation context, this would be less useful; I know that. This section is just a quick summary of how I see things in writing Progressive/Djent music but I use it now in any form of music.

I personally use these patterns when I write my music and to just recognize these patterns in any genre is a way to learn how music is structured.

I think that there aren't any rules in writing music. Some genres have its guidelines and in others these guidelines are actual rules. Some have basic structures, some complex and others have none.

I think this is still more a craft than a science. Follow the way you feel right and create ways in which you feel comfortable. I personally use these patterns.

Comeback Pattern

If you think of someone's comeback, you think most of all about some repetition that was not expected. Just like someone's making a comeback in sports.

If you write music, you can add a **comeback** to your song. Of course, you have the default chorus, verse... that reoccur; but these parts you <u>expect</u> to reoccur. And that's the main difference.

Sometimes these comeback parts are so well written that you can reuse them somewhere else, to come back.

Consequences:

- More variation
- More repetition (can be good and bad)

Example:

There're many songs that have a comeback in them. Try to recognize it in your favorite. Our song that has a good example would be **Greatest Hits**. Listen to the very beginning and to the very ending. At first the intro is used to start the song, and at the end to stop. At the end, it's just played one more time to have that maximum "comeback" feeling.

The song is finished and you still can hear the comeback.

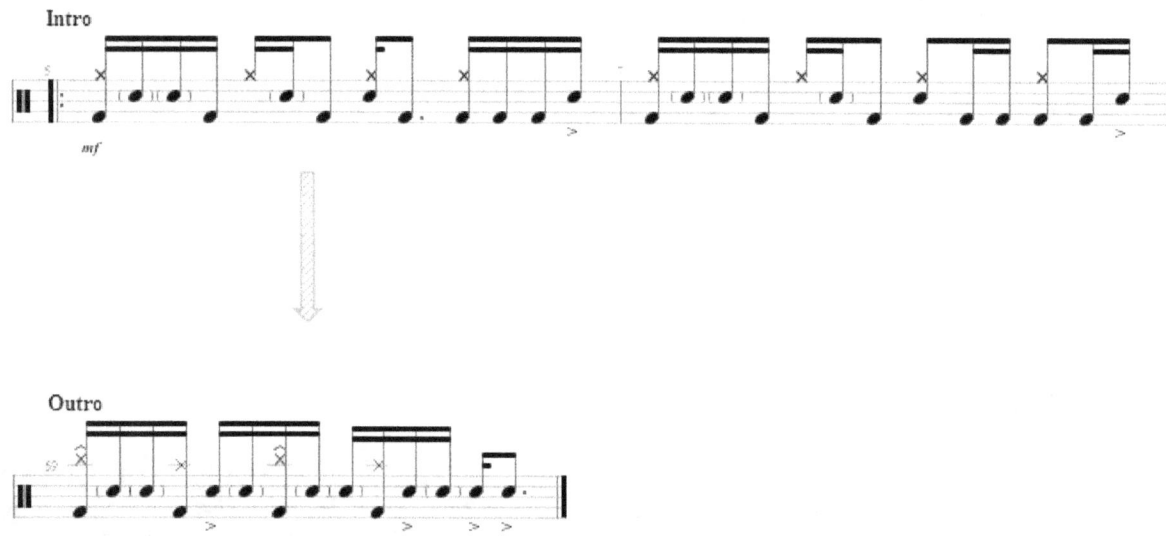

Climax Pattern

If you think about a **climax**, you think about an important part of your song. This part can really define your whole song and can be the reason people replay your song. It could also be written as a song for itself, like a climax-song of the album. The most important part is to really make sure that every listener really knows when the climax is played and can recognize it.

Sometimes the chorus is the climax of your song, or the melody that keeps repeating in your head even if the next song plays. But actually, it can be any part that dominates the song.

I think it's also important that you don't go to fast from your climax to the next part, otherwise it would feel like an *Anti-Pattern* to me, forced. Try to hold the energy of climax in the next part.

If your climax is your solo, it could help to add a *Bridge* to go to the chorus instead to play the solo directly to your chorus. If your chorus and solo play a significant part of your song, you have two climaxes. This way your chorus after the solo immediately has some more energy left of the solo.

Following diagram shows a structure where the climax acts as a glue to combine two choruses. This could be a solo for example (that's the case with our song **Not in Portland**).

| verse | chorus | climax | chorus |

Consequences:

- Adds a dominated part to your song
- Working your way out of the climax can be hard and needs some thinking

Example:

I try to have a climax in every song I write. It even helps me sometimes to think back at some songs, just by remembering the climax. **Exodus Pt. II** has a really nice climax and *Build* in front if it that really helps define the energy of the climax.

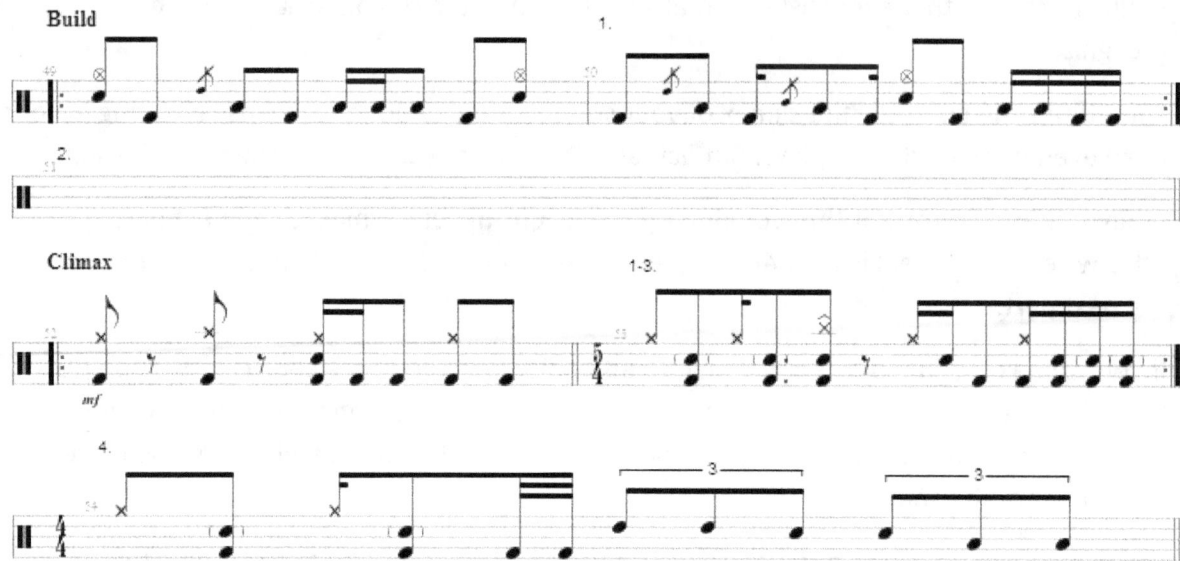

Group Pattern

Sometimes you have pieces of music that are very difficult to place somewhere else. This can happen with a chorus and a pre-chorus. It makes sense to have the two of them together because they "flow" into each other. That's when I *Group* them together and reuse them both when I want to repeat one of them. See them as one piece.

This sometimes happens when playing a chorus and right after it an *"Alternative"* version of the chorus (see *Alternative Pattern*). This way, you give the chorus more room in the song.

By bundling pieces together, you add some predictability because the listener will know the second-time what part will come next because you play them as a *Group*.

| verse | pre-chorus | chorus | verse |

Consequences:

- More predictability
- Could make your song longer by reusing them all

Example:

Our song **Orientation** has a good example of the *Group Pattern*. We have two choruses in this song, and each chorus is introduced with a part that's always played upfront.

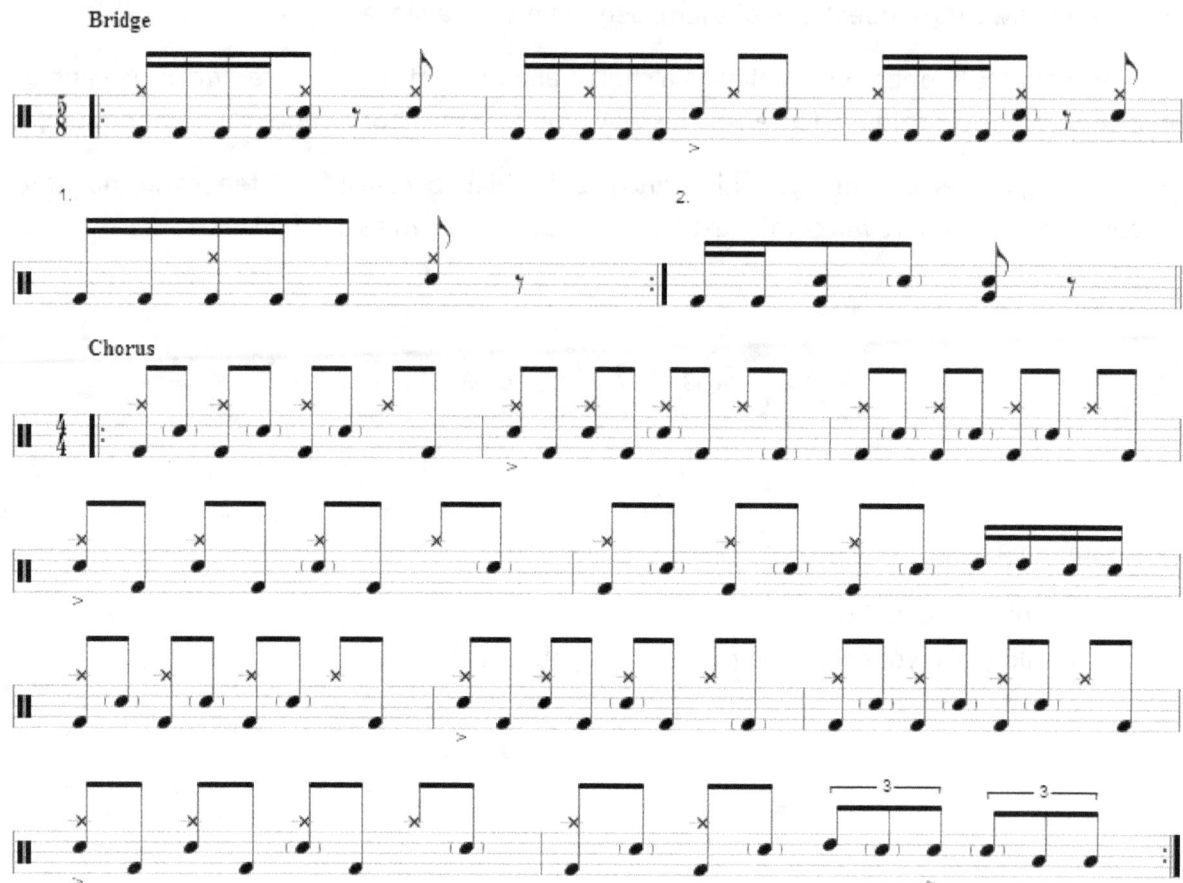

Break Pattern

Maybe people don't always think that every song needs a *Break*. But personally, this was one of the first lessons I learned from my father (which has a remarkable experience with music).

> *"Every song needs a Break"*
> -Johan Moreels

With the term "break", I mean literally "break". Like a lunch break. It's the part where everything is kind of calm. A relief, a pause. Most of the time I play this break a lot softer than the other parts of the song.

This also can hold the attention of the listener and maybe get him/her prepared for the next part (which can be a *Build*).

In my opinion, adding a *Break* to your song lift the song to a higher level in variation, dynamics, and quality.

Consequences:

- More variation and dynamics
- Hold the attention of listener

Example:

Every song in this book (the transcripts are included) has a *Break* in it. So, I'll just take one I really like to play. This one is from **Exodus Pt. I** where the *Break* ends with a *Build*.

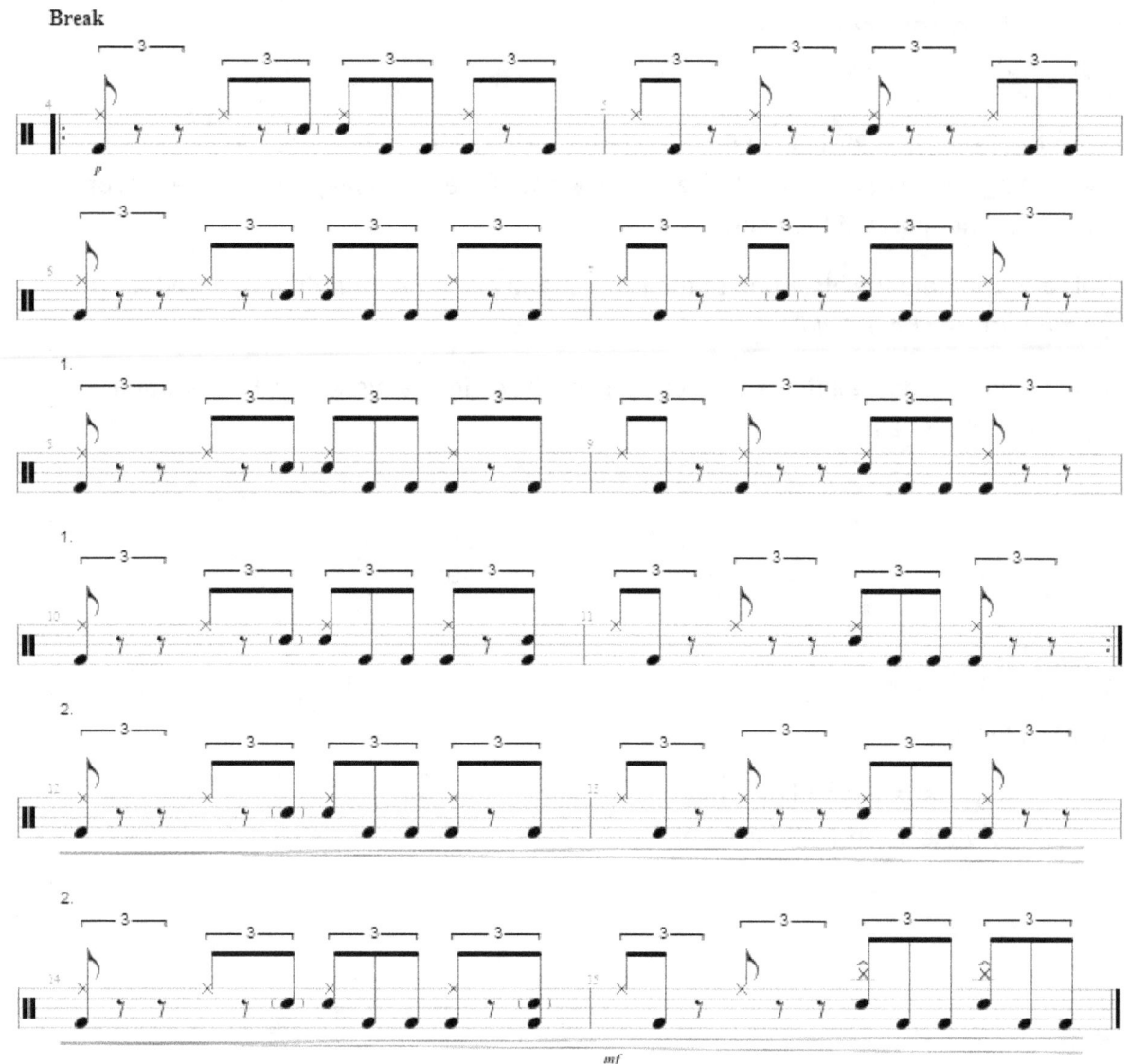

Build Pattern

To "build" is to expand from one part to another (could be a **crescendo** but you can also build something without playing louder). The actual build can happen in a whole song where you start from nothing and build up to a *Climax*. Or in reverse where you start from a very dominant part and *Break* down.

A *Build* comes mostly together with a *Break*. Otherwise, you have nothing to build up from, right?

The feeling that you get when you hear the song building up to a *Climax* is an enormous energy boost. You feel that something is coming.

Consequences:

- Boost in dynamics
- Building energy

Example:

All our songs in this book have also a *Build* in them; but the one from **Exodus Pt. II** is a nice one. The *Build* is starting before we're playing the *Build*. You can feel the energy boosting before we play the *Build*. Nice eh?

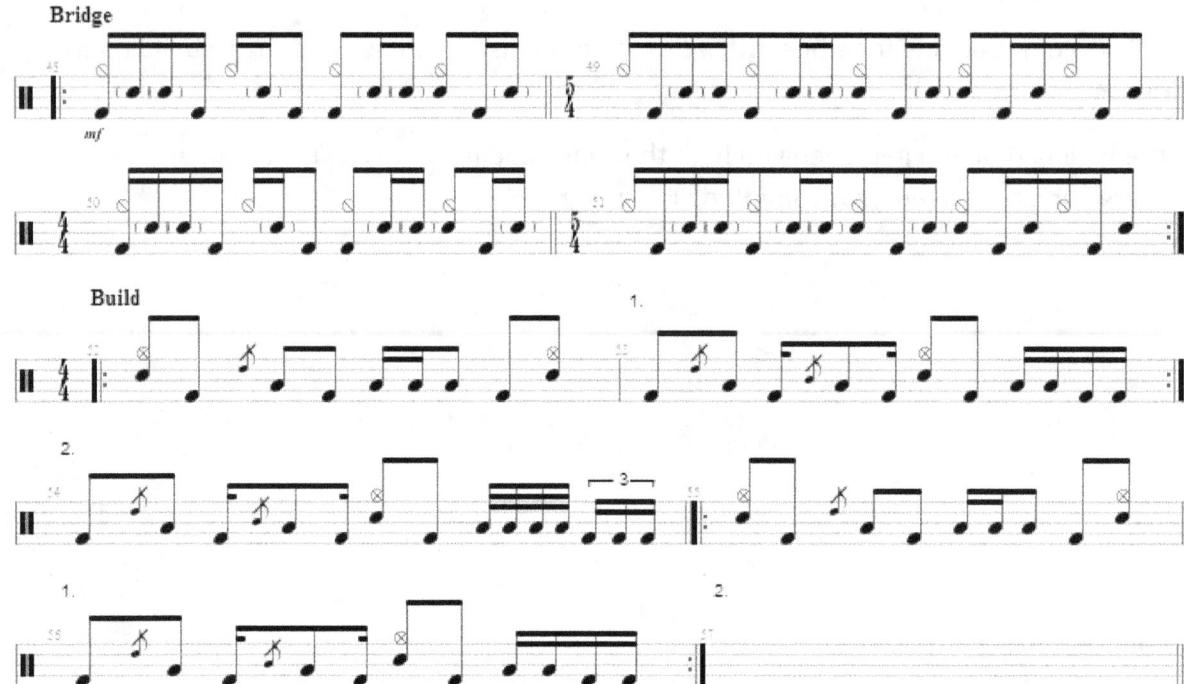

Alternative Pattern

When writing music, it's sometimes useful to play a part again but just a little different. These little differences can be very subtle: some instrument that plays more dominant, a higher tempo, and extra layer, ...

By playing the part in an *Alternative* way, you make a path to the next part or by increasing the attention to the previous part.

Sometimes this can be used to *Hold* a bit more to a certain part instead of shifting to another part too quickly.

Consequences:

- More repetition (can be good or bad)
- More dominant parts

Example:

The song **Greatest Hits** has a climax which is played in three different ways – three alternative ways:

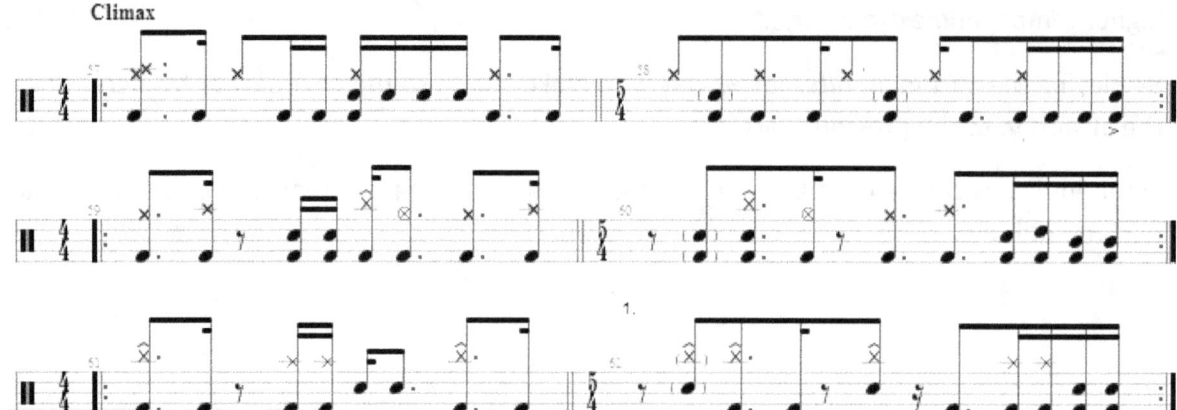

Reference Pattern

With a *Reference*, I mean a subtle *Reference*. Subtler than a *Comeback* because with a comeback, you want that everyone has seen you. And a lot subtler than an *Alternative* because that is a explicit reference.

This pattern is very subtle and is more for your subconsciousness. The song **Beat-It** from **Michael Jackson** is a perfect example. In the intro, there's a background melody that's played once. Very subtle. Later in the song, the melody is played more explicit and everyone has that feeling of *"Yeah, I heard that once before"* even when it's the first time you heard the song.

That's because your subconsciousness heard that little subtle part.

I think it's a good thing that we place *References* between different parts in our songs. This way we have a good relationship in our songs and not a scrapbook of music parts.

Consequences:

- More relationship between your music parts
- Adds an extra layer to your parts

Example:

Our song **The Incident** has a good example of this as well. The *Break* and chorus has something in common: the last part of every even bar.

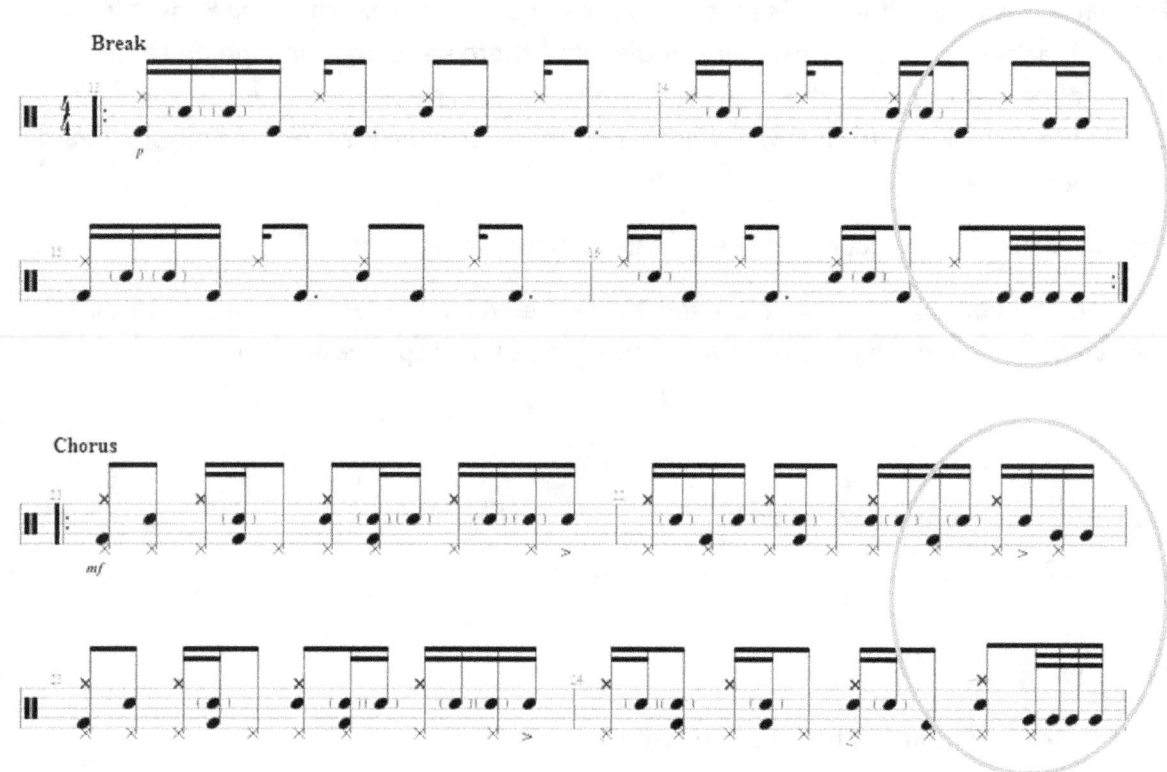

Bridge Pattern

A *Bridge* is a standard term in the music world and is used to glue two pieces together. A *Bridge* can help in a context where two pieces doesn't look like they fit but do fit by placing a *Bridge* in between.

If you have a solo and you want to go back to your chorus, it would be useful to first play some "other part" instead of directly shifting to the chorus.

If you place several bridges side by side, it may sound forced and not "musical". So maybe the pieces don't fit after all. I think there are many songs with bridges in them but don't force it.

Except of course you want to sound forced, which in some circumstances is needed.

Following diagram shows a *Bridge* between a solo and a chorus:

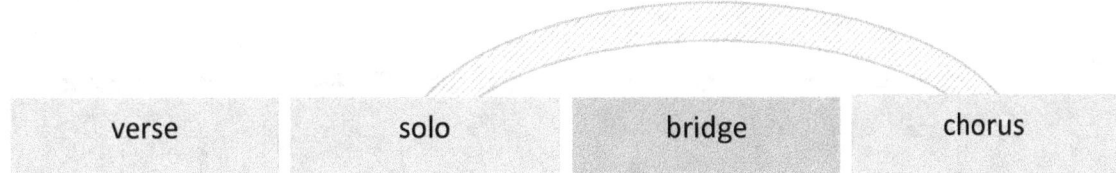

Consequences:

- Combines two pieces who in the first place won't fit
- More variation

Example:

In this case, I will show you a *Bridge* from the song called **Catch-22**. We have *Climax* in place and we want to go back to the chorus but the energy of this *Climax* is still present and it would feel forced. That's why we placed a *Bridge* that acts as a *Break* in between the two parts.

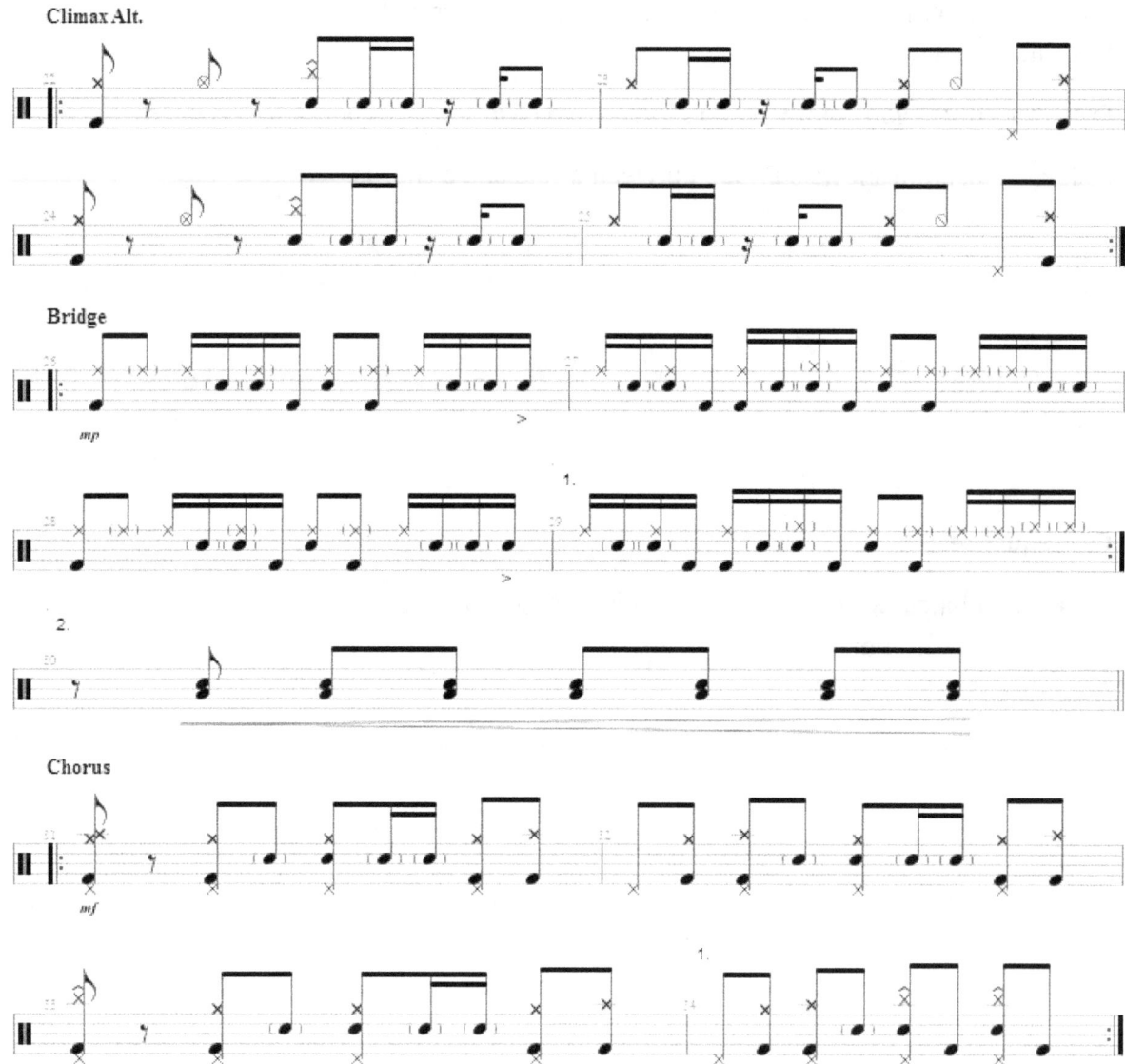

Surprise Pattern

When we place *Surprises* in our songs, we want to decrease the predictability of the song. Dance songs are full of predictability because people need to dance. So, they must have some sort of way to quickly predict how the song will evolve. In the Progressive world, it's just the way around; than we want to surprise the listener and bring them the unexpected.

Too many *Surprises* in a song can lead to a less musical song and a more forced song.

A *Surprise* in Djent could be an odd signature that's played after an 4/4 for example. When the odd signature comes in, you can't nod your head anymore and that's where you can surprise your listener.

Or you can play your part three or five times instead of the standard four times. There's so many ways to surprise people with music.

| verse | break | surprise | chorus |

Consequences:

- More variation
- Makes the song more interesting

Example:

What at first is a surprise is the second time maybe something else; but what I find a *Surprise* is the *Bridge* to introduce the *Break* in the song **The Incident** because it's played in a 4/4 + 9/8 and it's surrounded by parts played in 4/4.

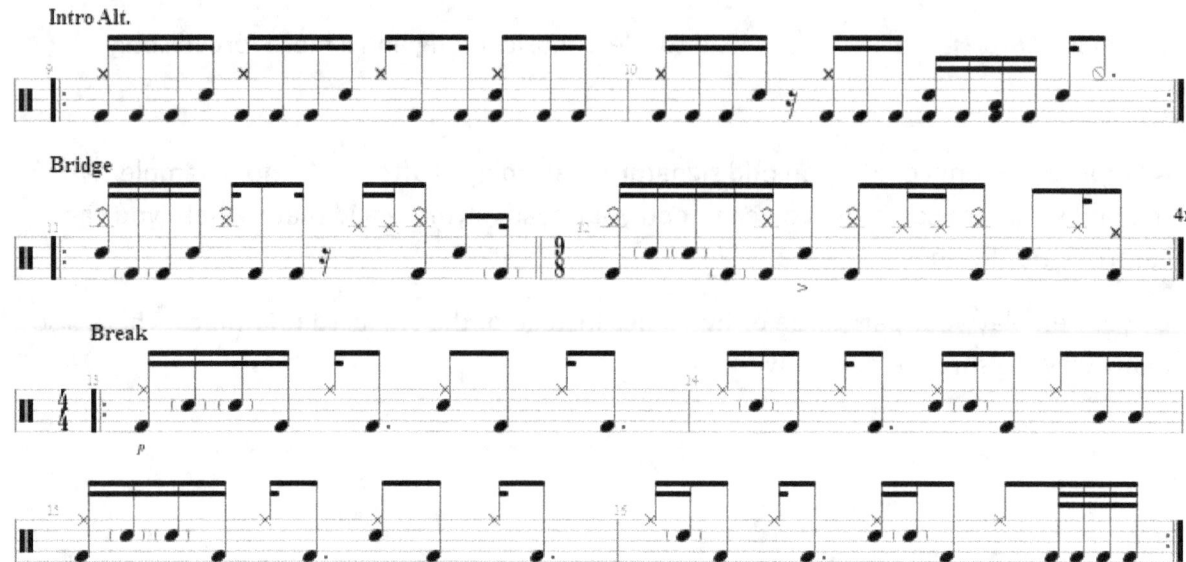

Hold Pattern

Sometimes you have too many dominant pieces in your song that it doesn't feel right to go directly to the next part. You could play an *Alternative* but in some cases you have finished that part and you need something else. That's when you can place your dominant part *On Hold*.

You can for example take some part of a solo (a melody maybe) and put it in a different context that will be your other part but still with some kind of reference to the solo. This other part could be a *Bridge* for example but doesn't have to be.

Instead of introducing a Bridge you could also play the melody on top of the next part as an extra layer so you have still the same feeling from the solo but in a different context.

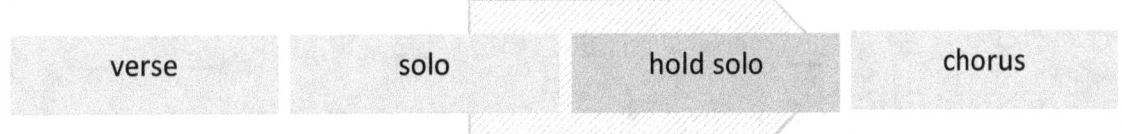

Consequences:

- More relationship between parts

Example:

The song **Not in Portland** has a *Break* somewhere in the beginning of the song, but we can't just play the intro directly to this *Break*. So, we introduced a *Hold* that we placed in between. You could see it as an *Alternative* but this *Hold* part is so different from the original that it doesn't feel like an alternative but a new part.

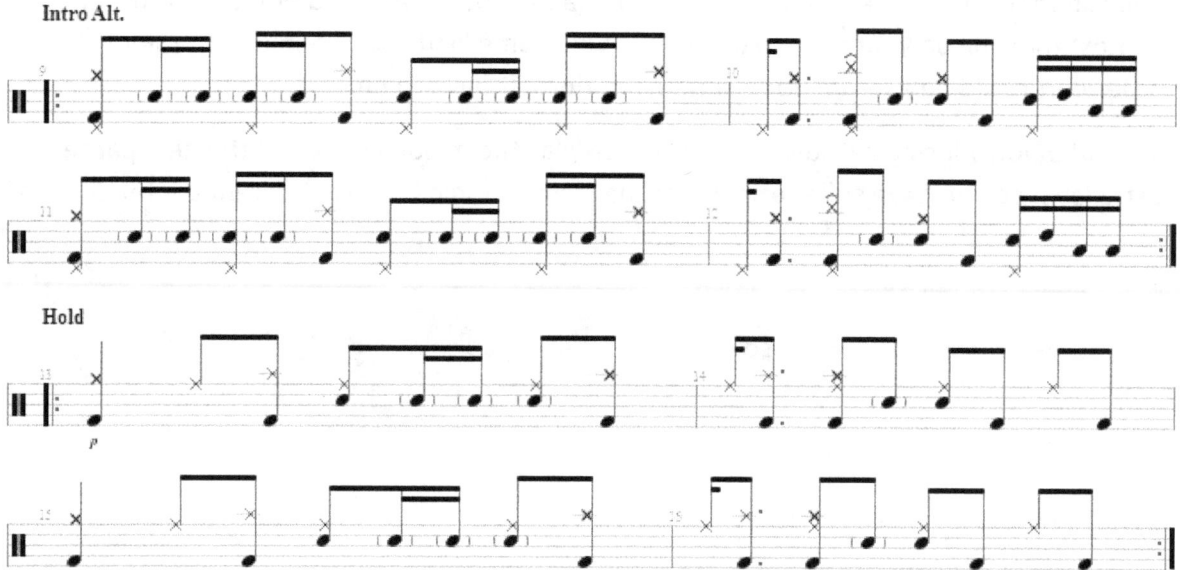

TRANSCRIPTIONS

As last part of this book, I will give you the transcriptions of the songs I've written for the project **Via Calypso**. These songs have interesting structures and some easy to grasp *Music Structure Patterns*. **Orientation** has a structure in which the composition is really challenging; **The Incident** has a very nice building-up feel around the whole song...

For more information, see: **viacalypso.bandcamp.com**

Enjoy!

Via Calypso – Lost...

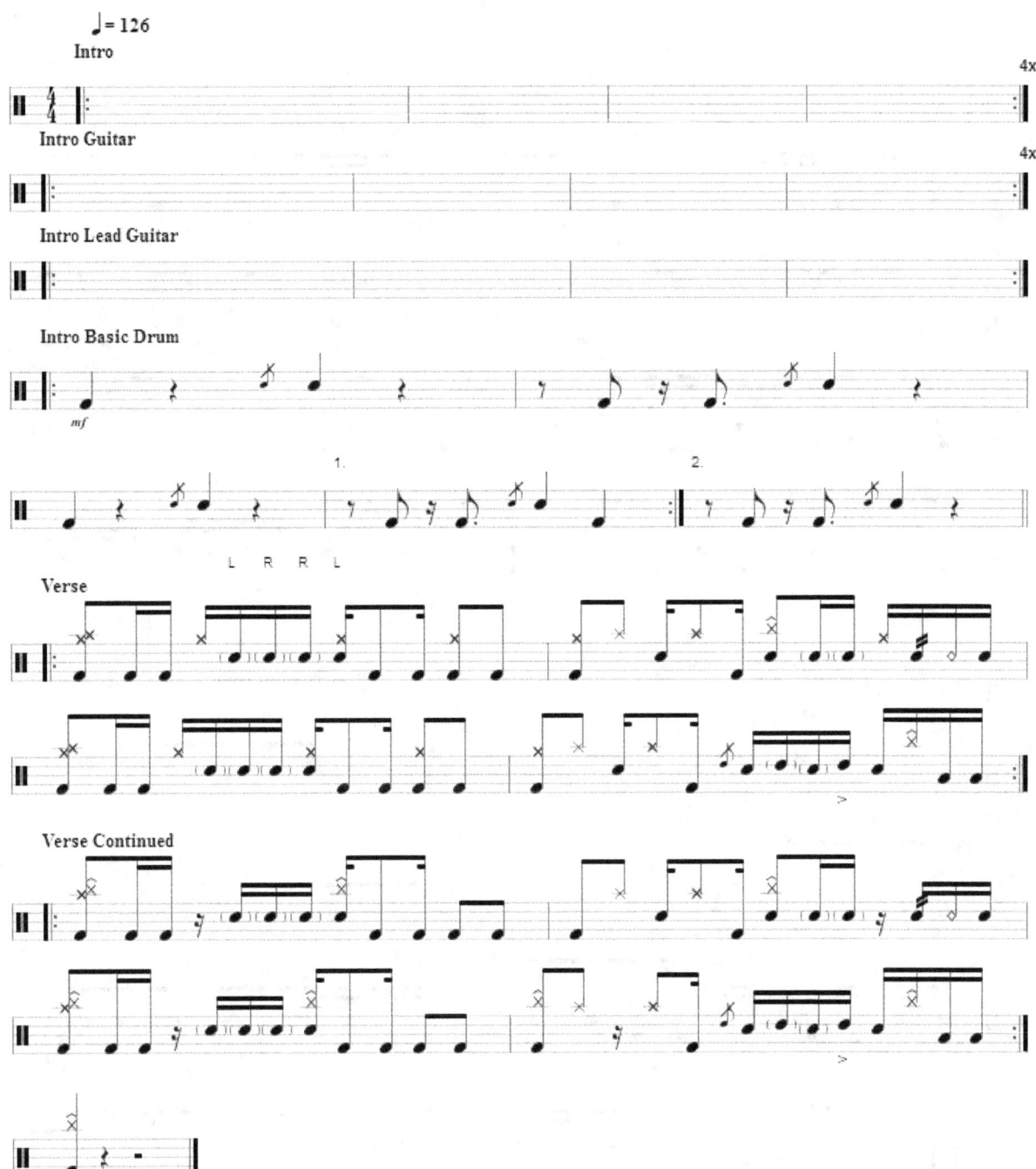

Via Calypso – Orientation

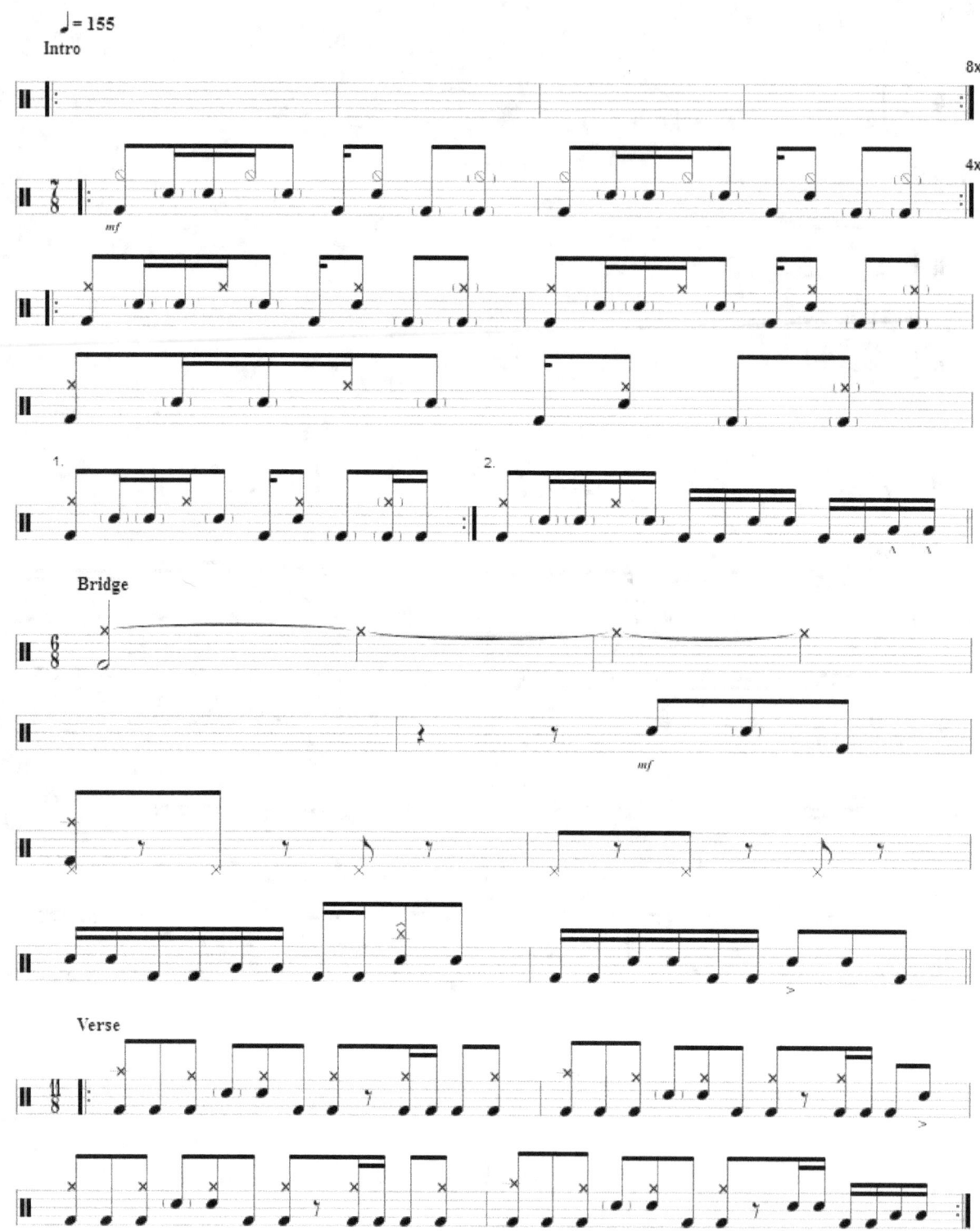

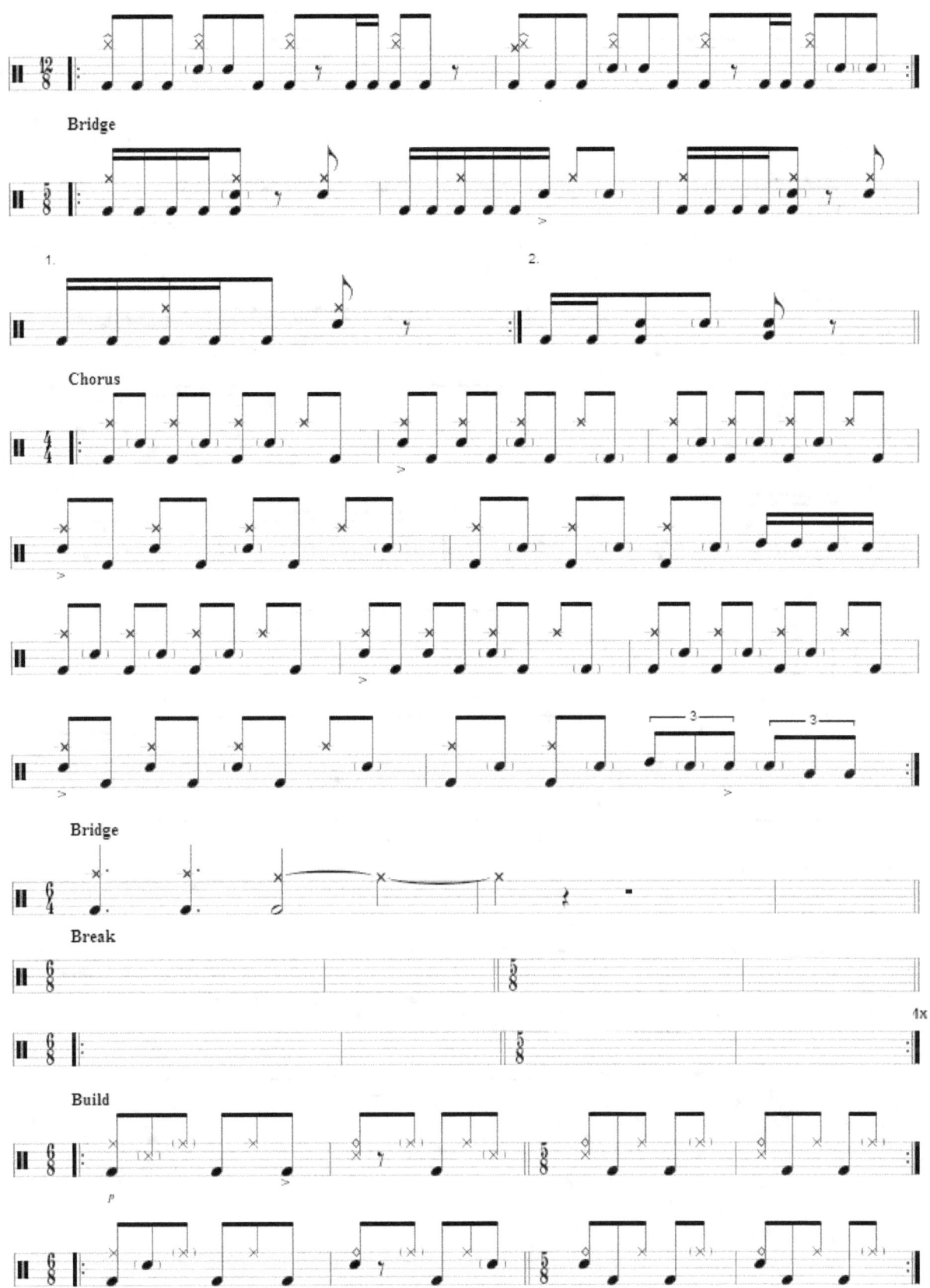

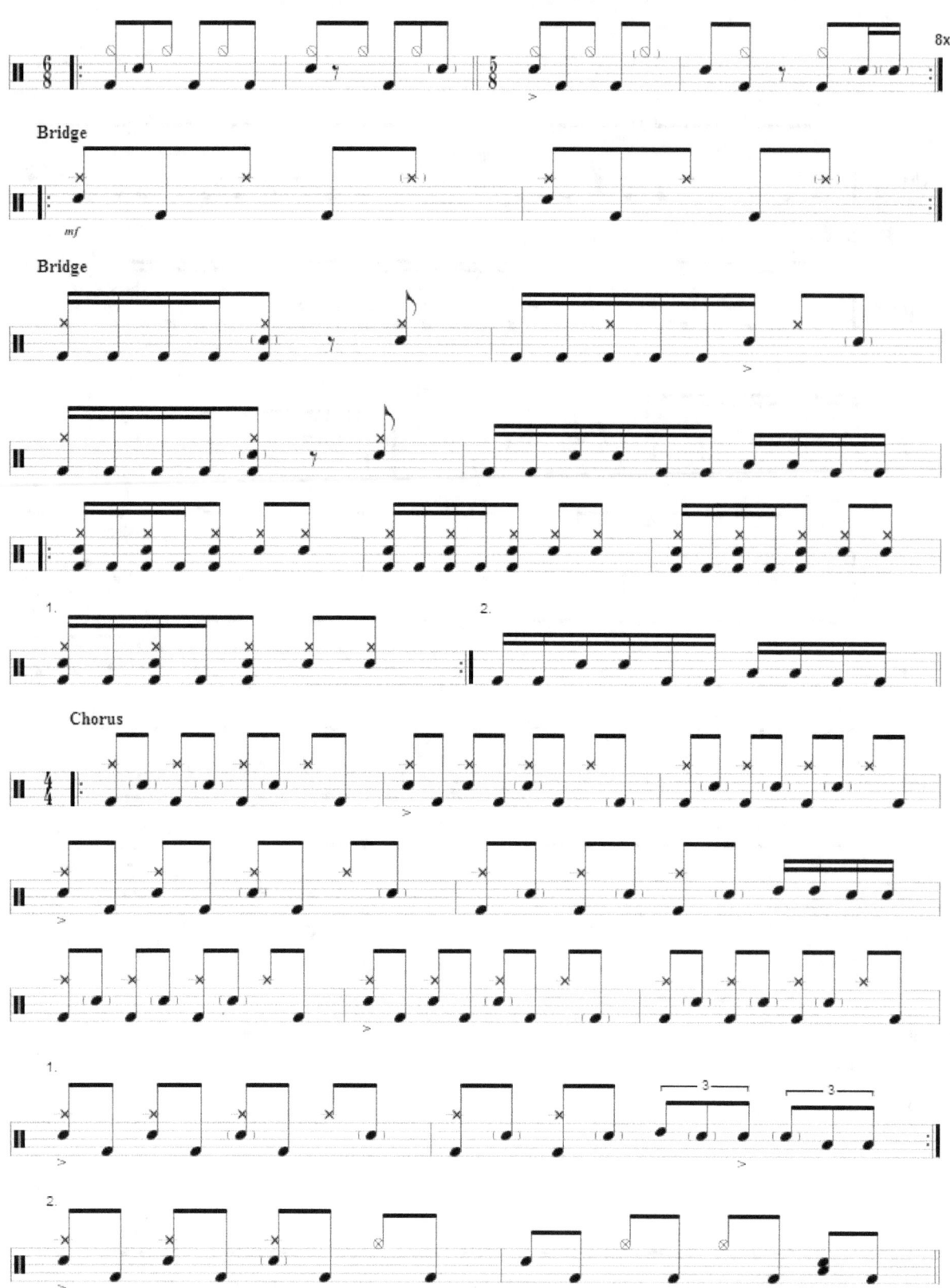

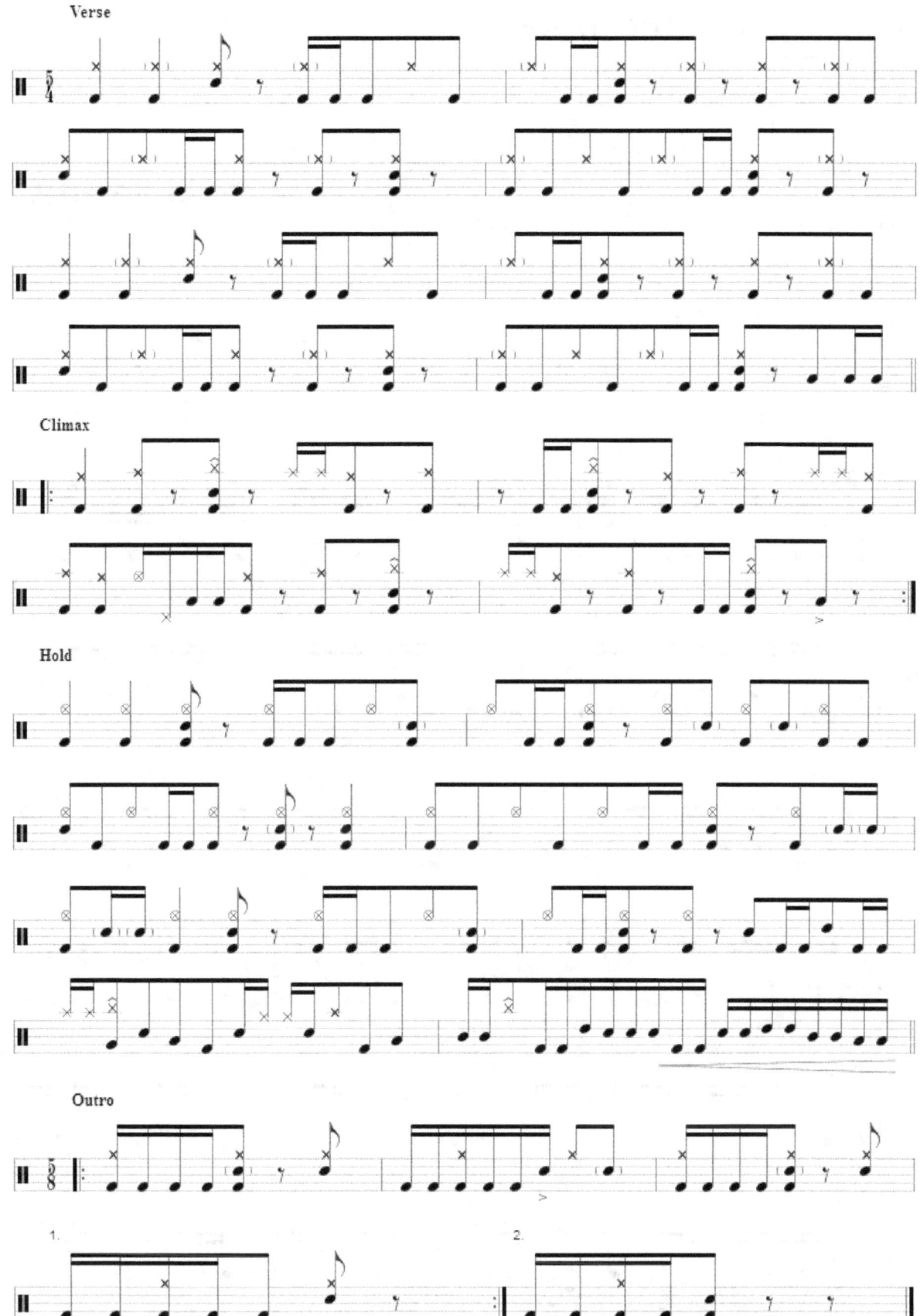

Via Calypso – The Incident

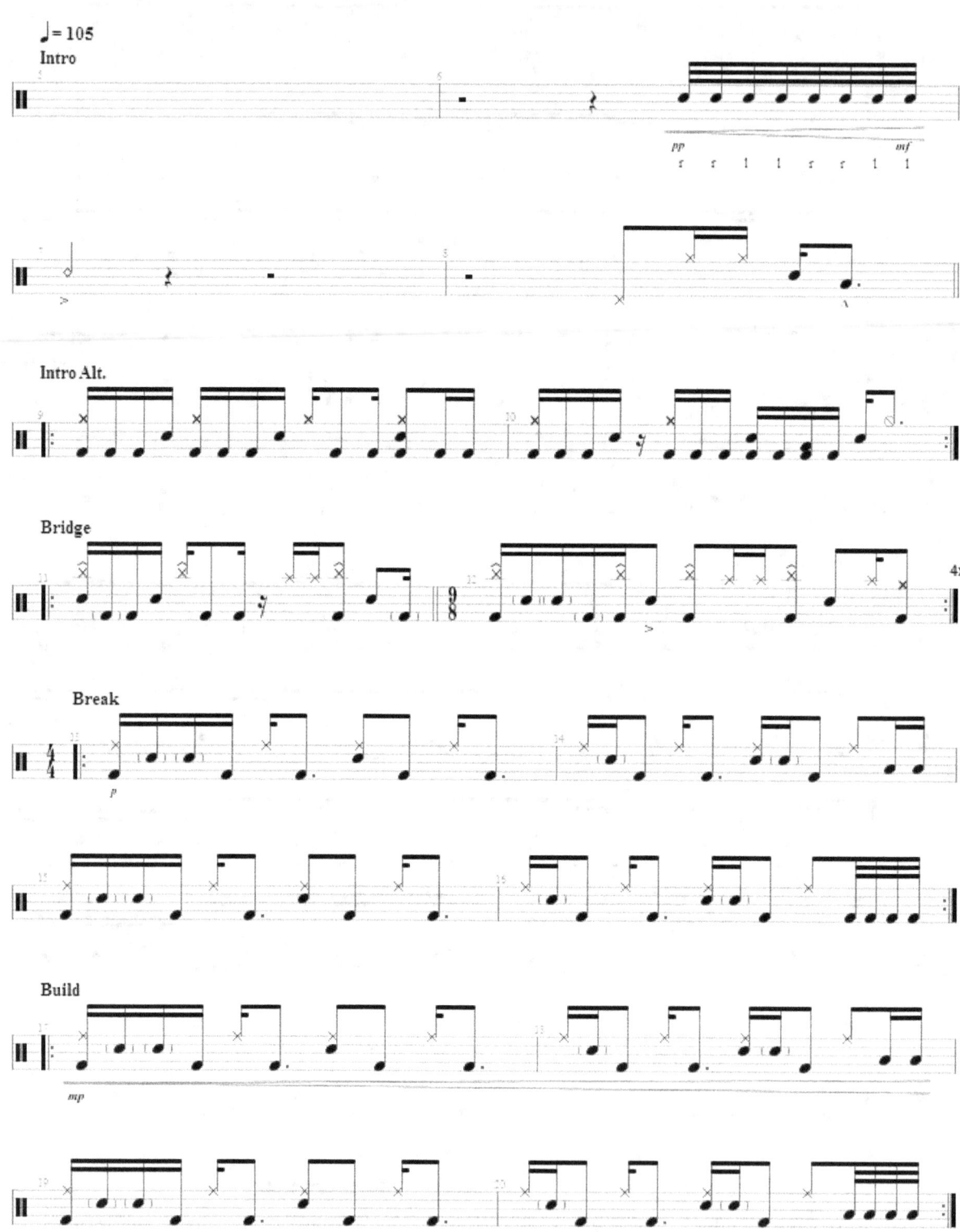

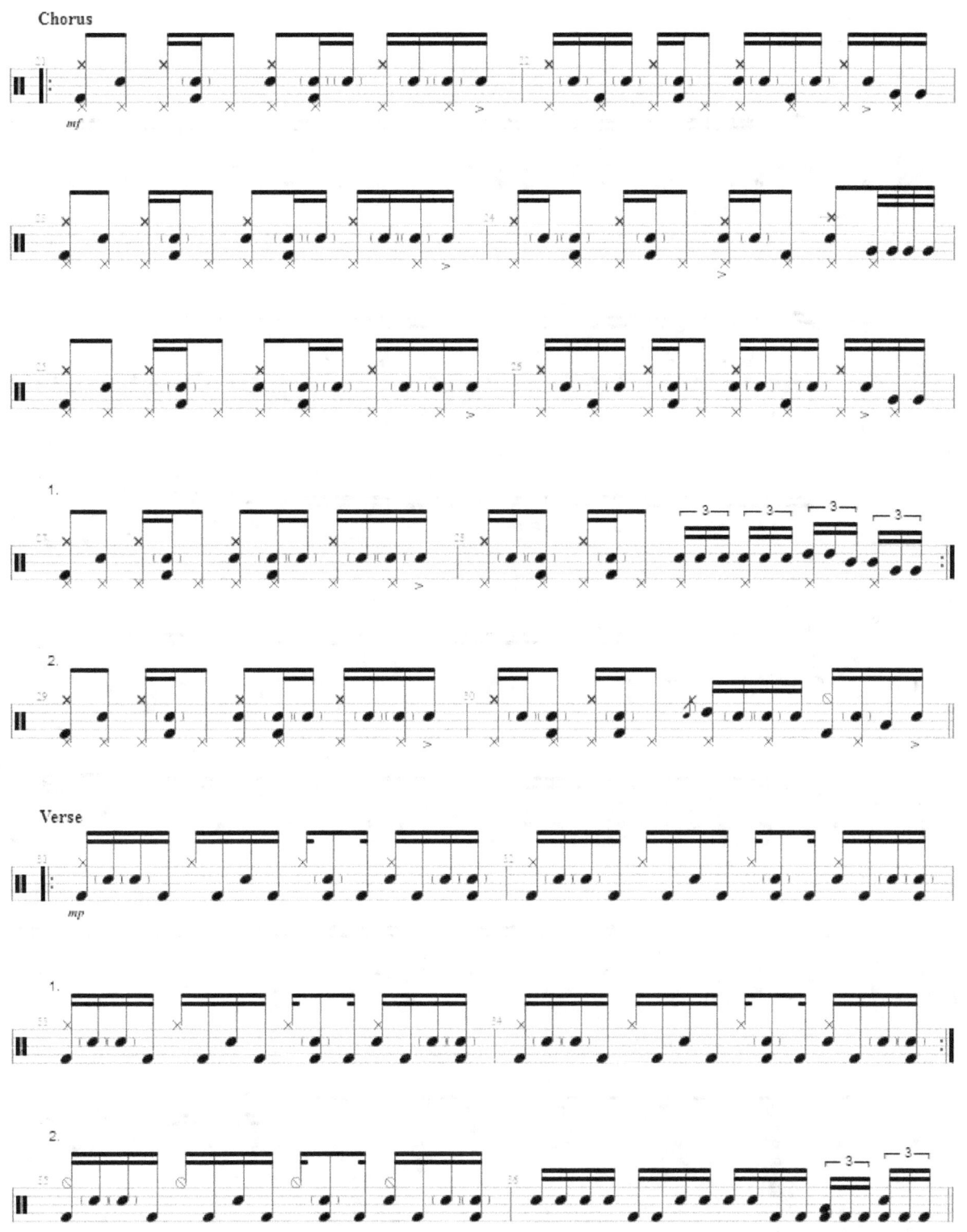

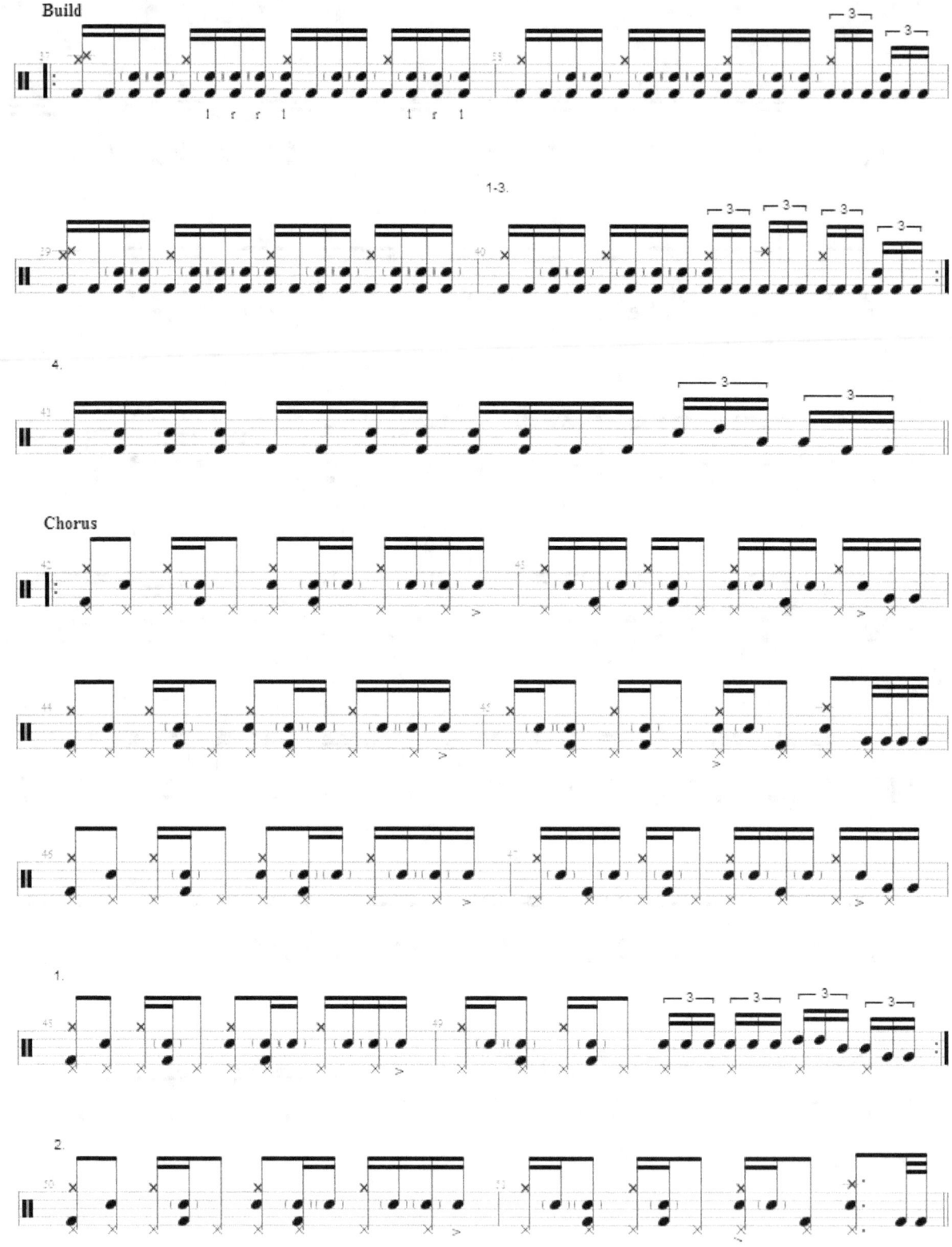

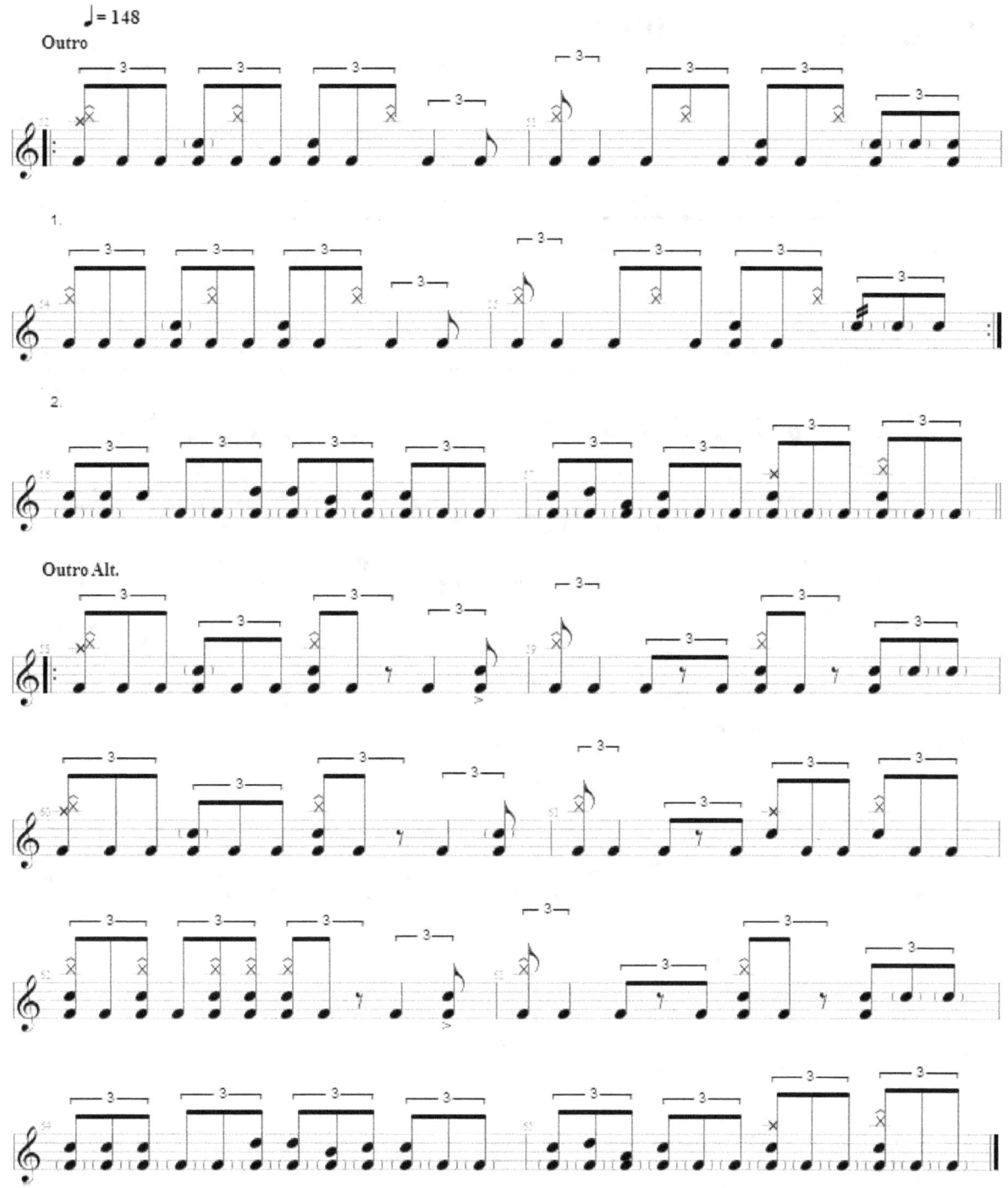

Via Calypso – Exodus Pt. I

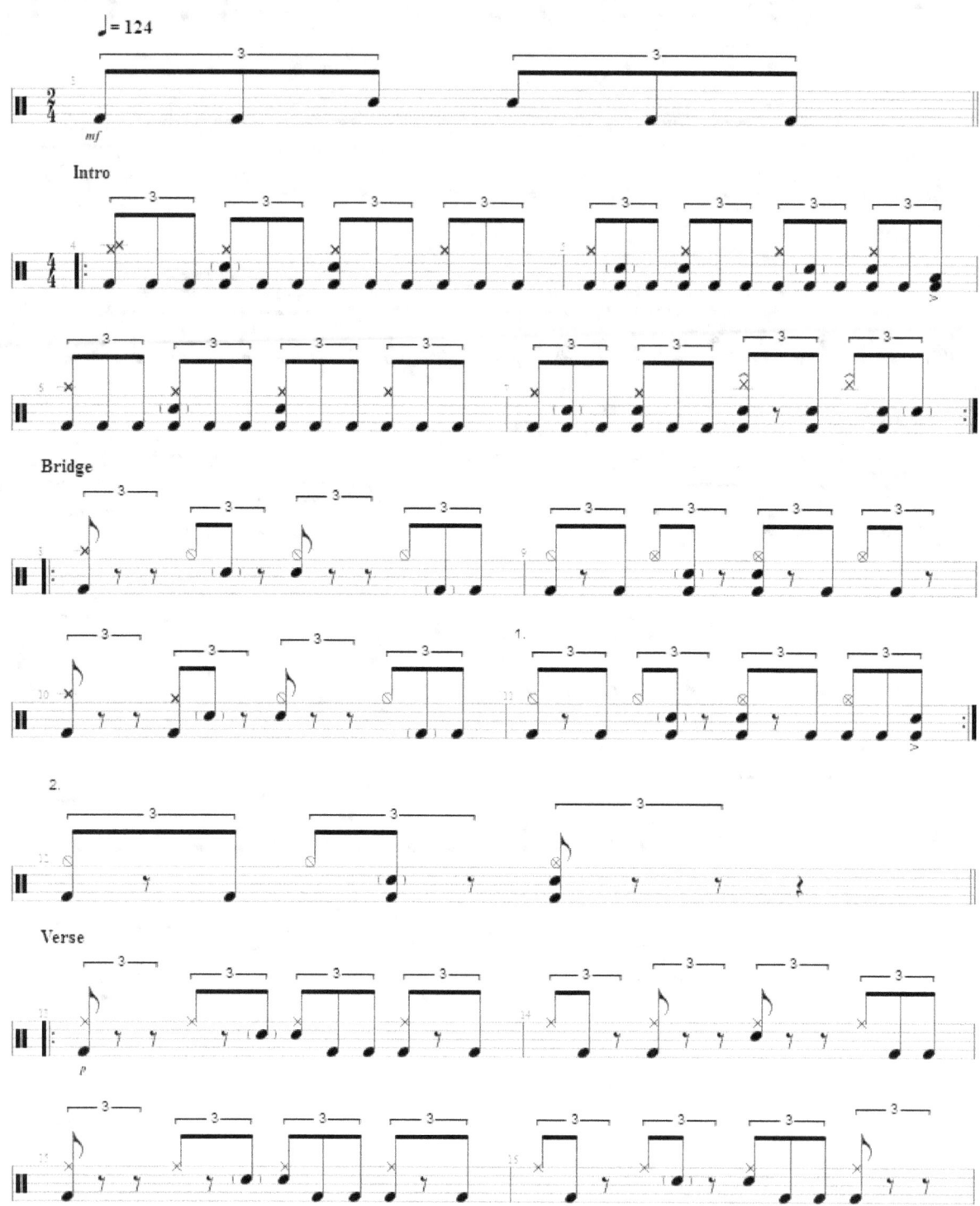

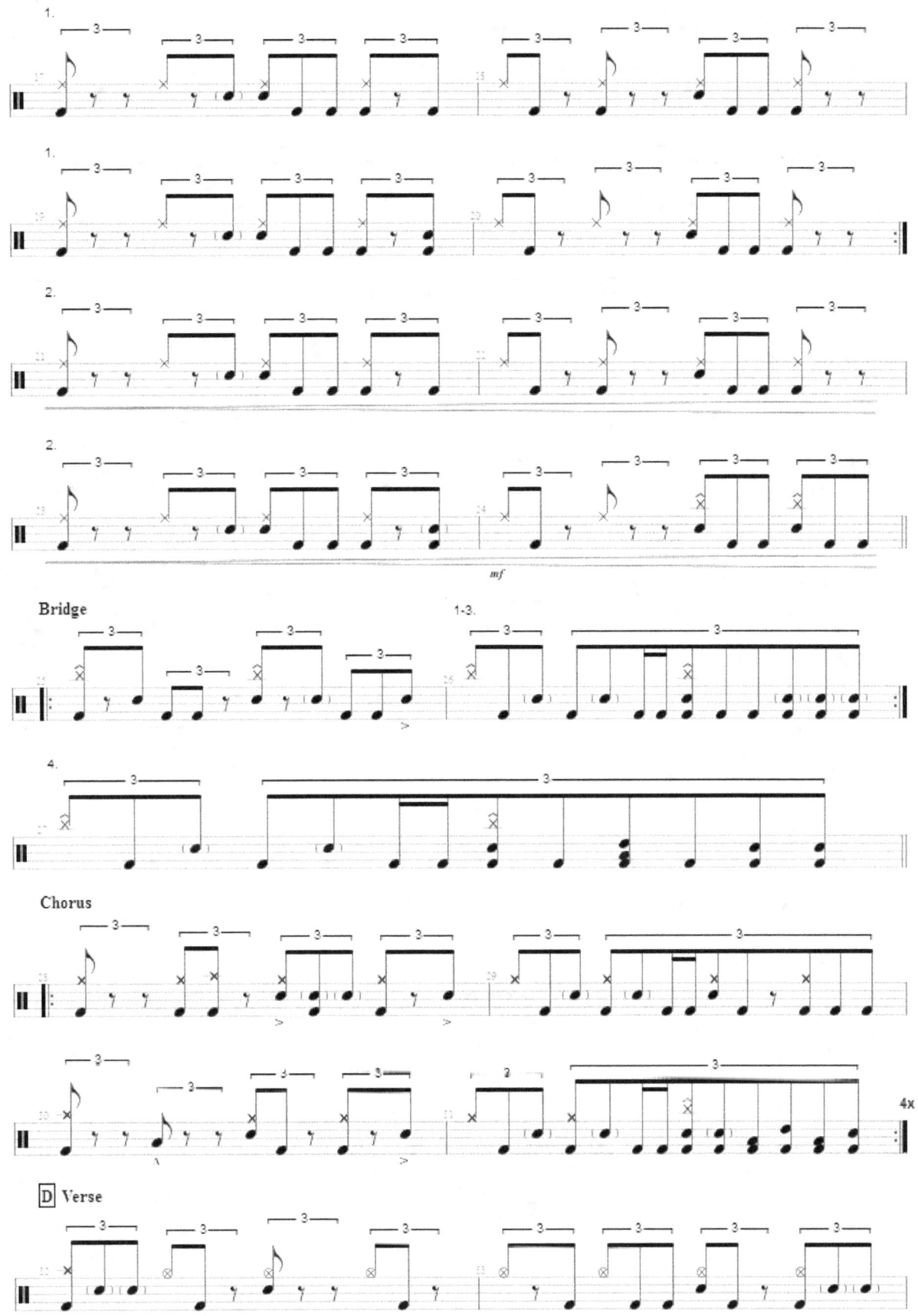

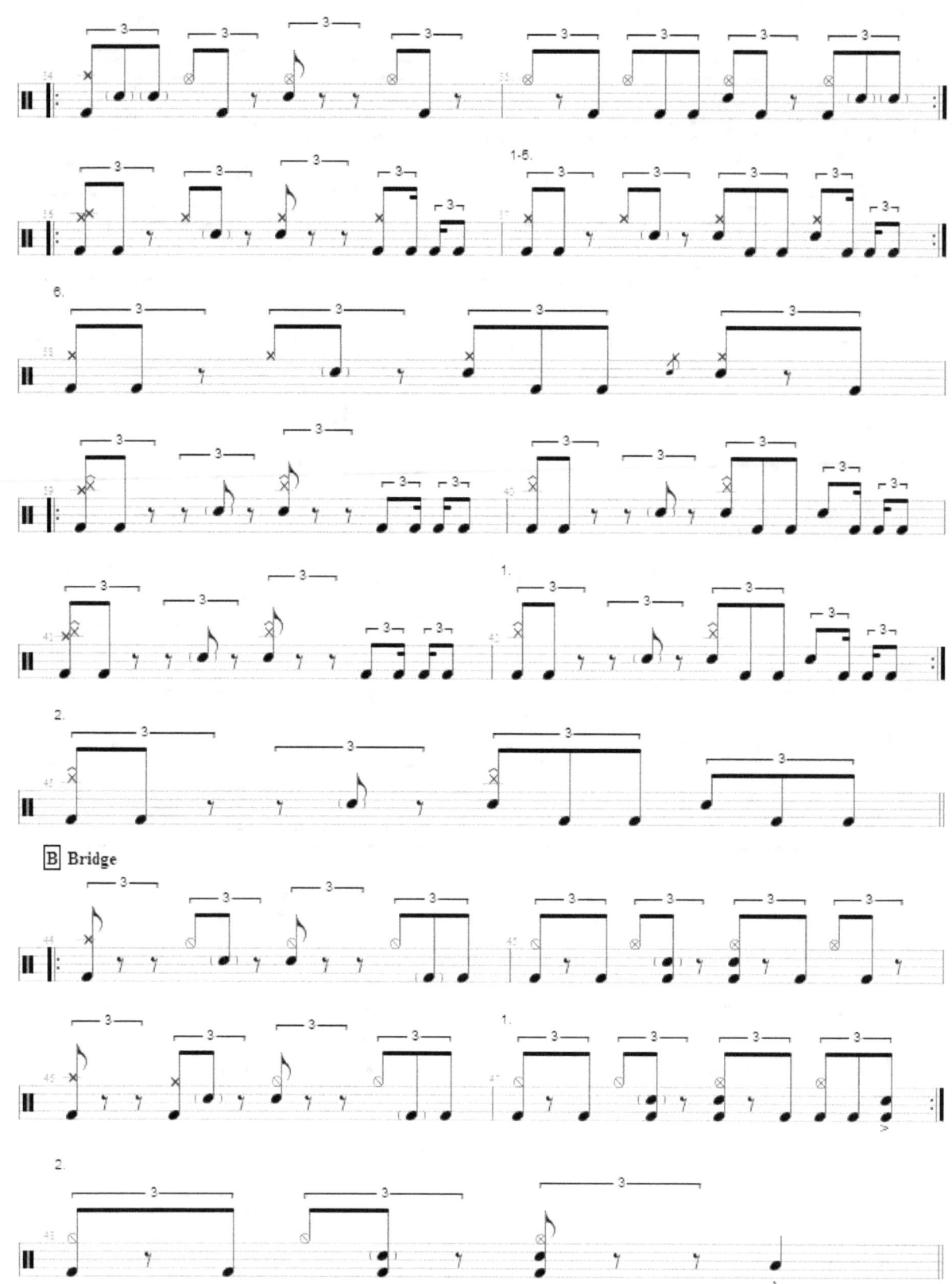

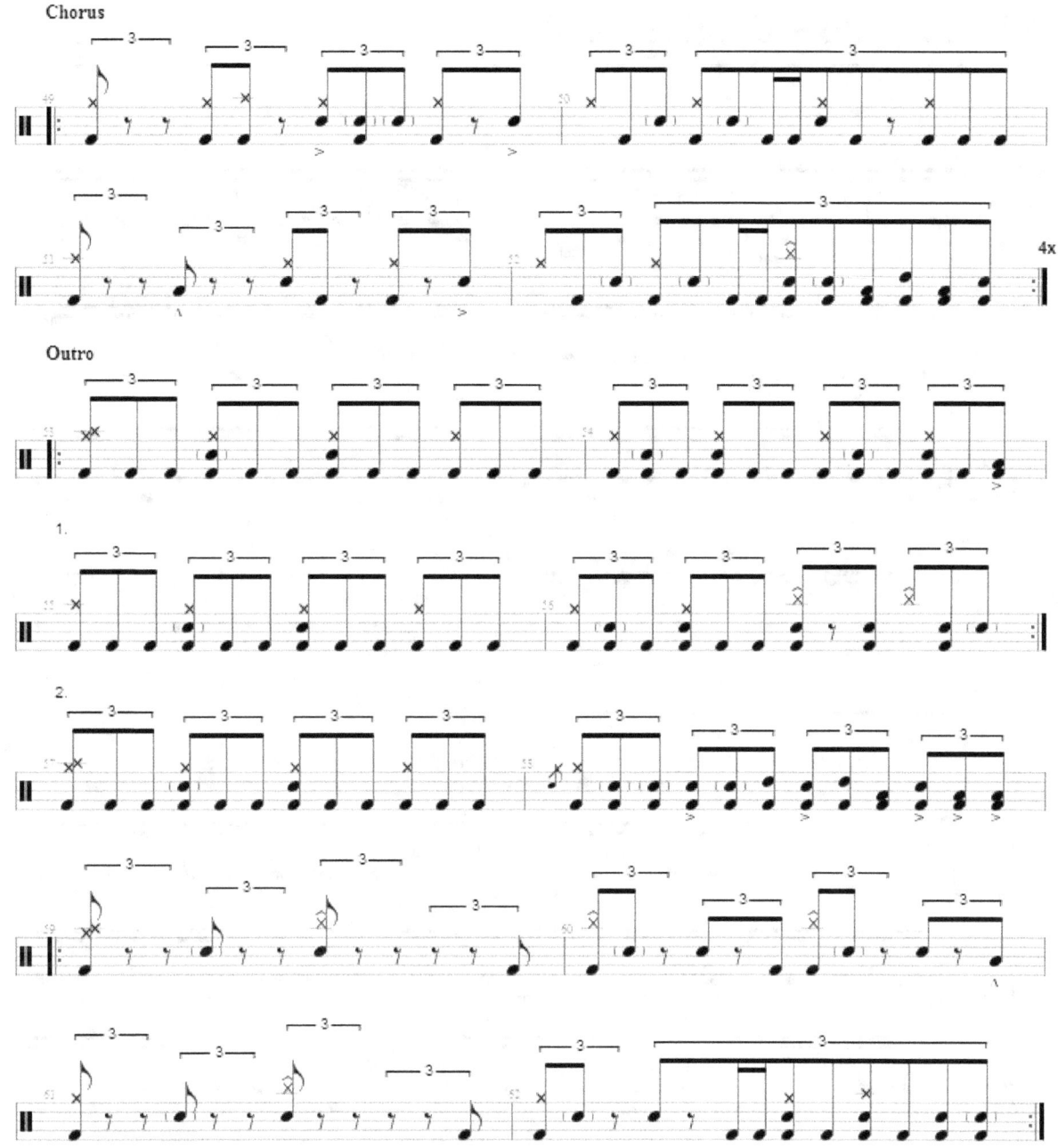

Via Calypso – Exodus Pt. II

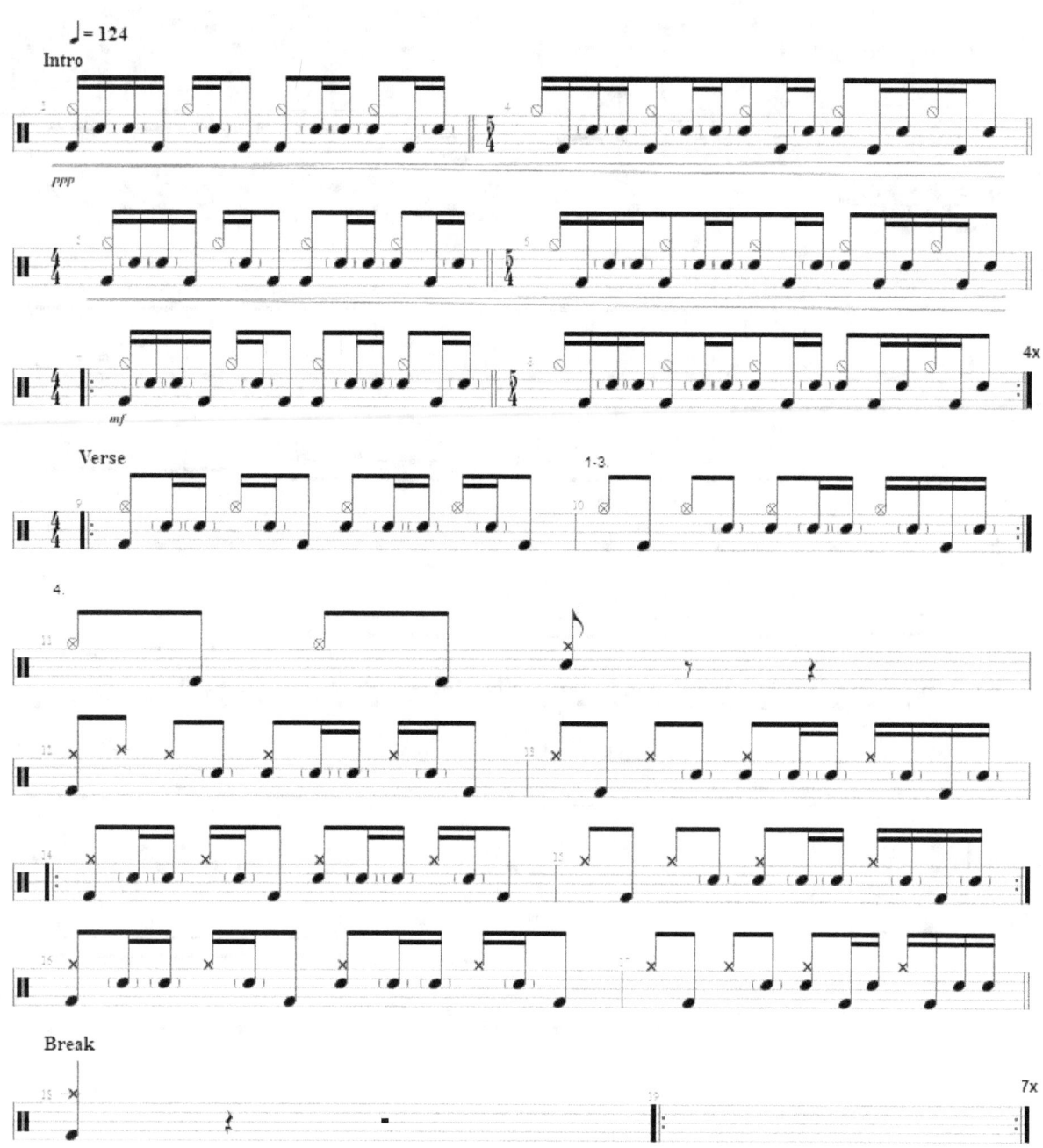

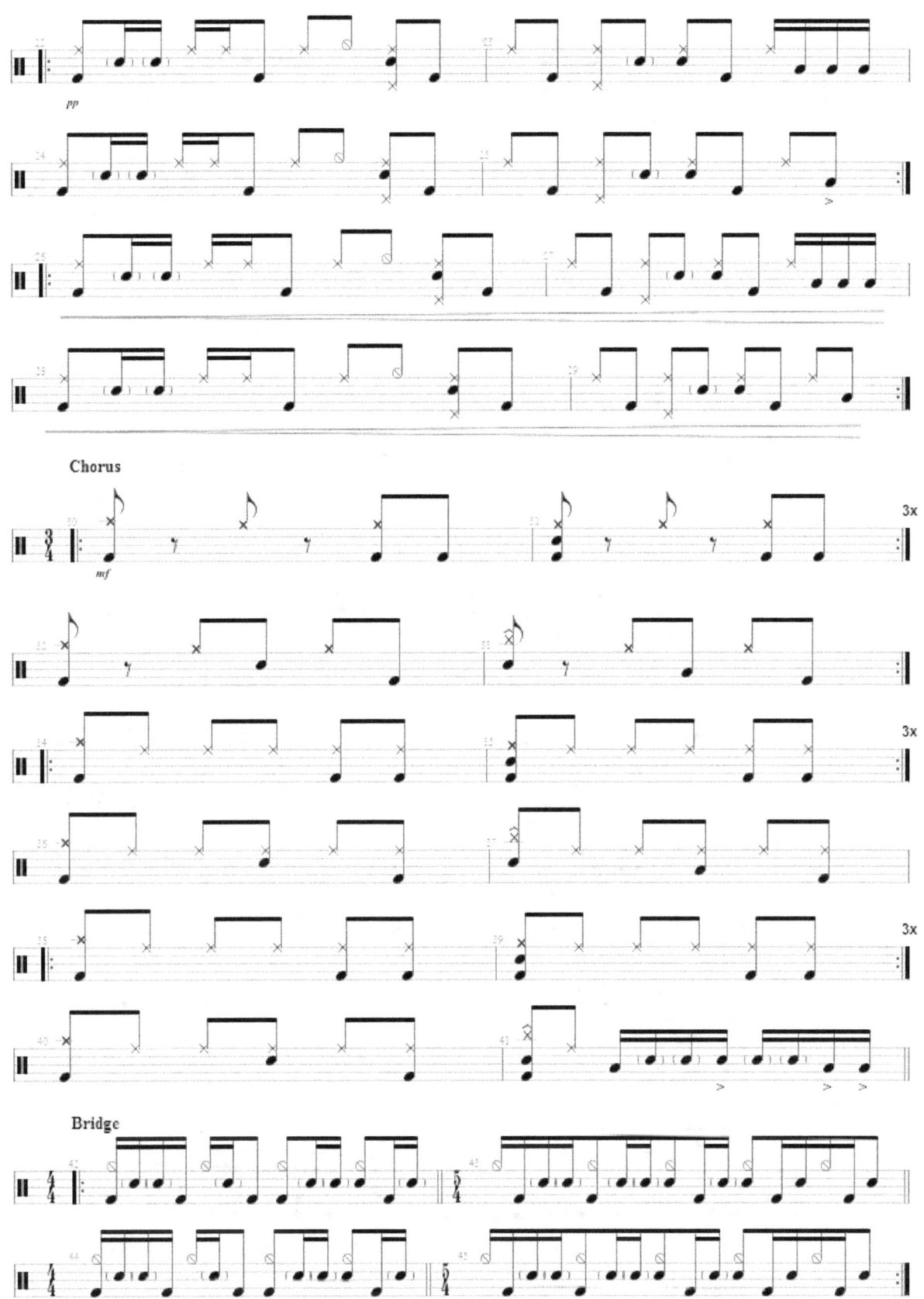

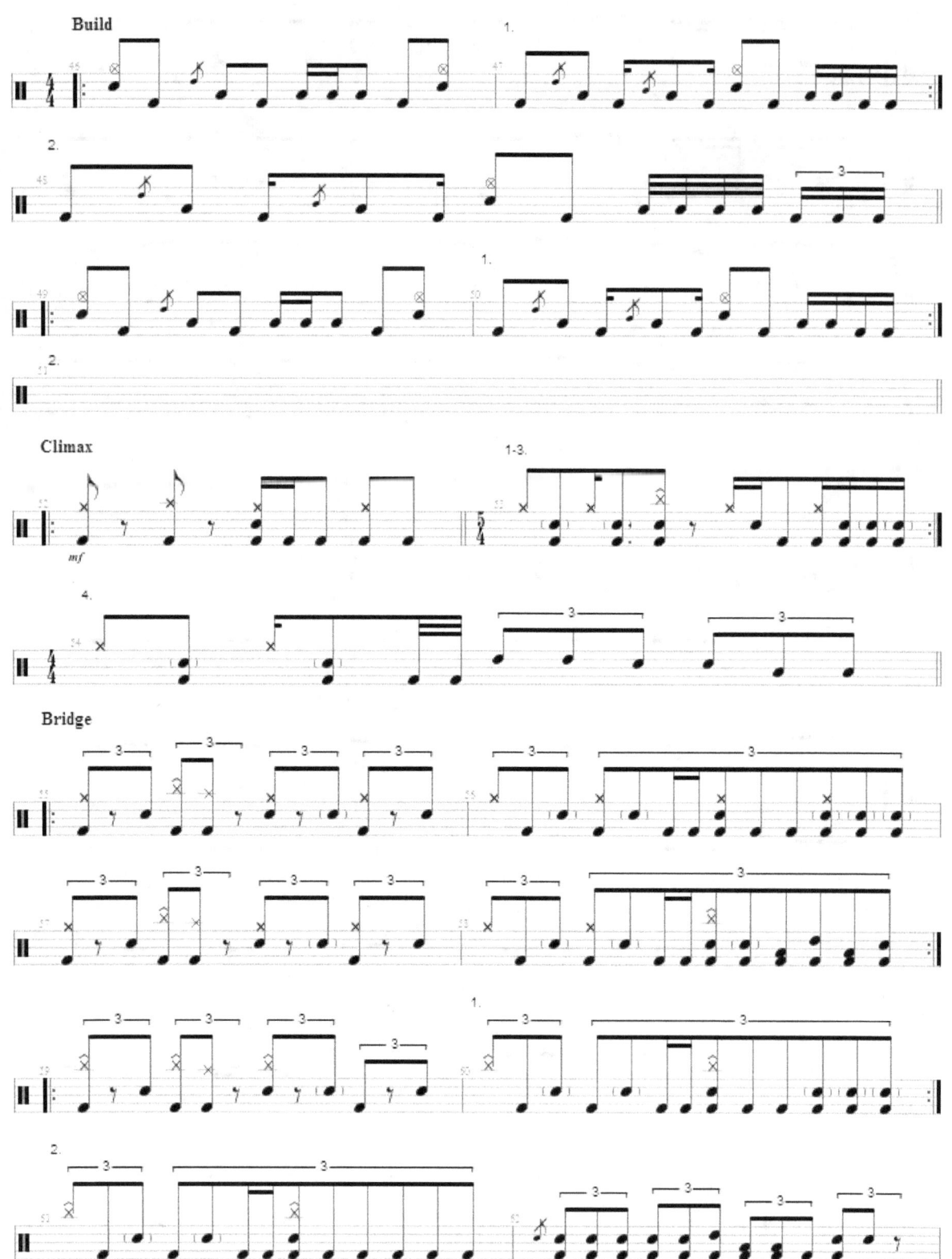

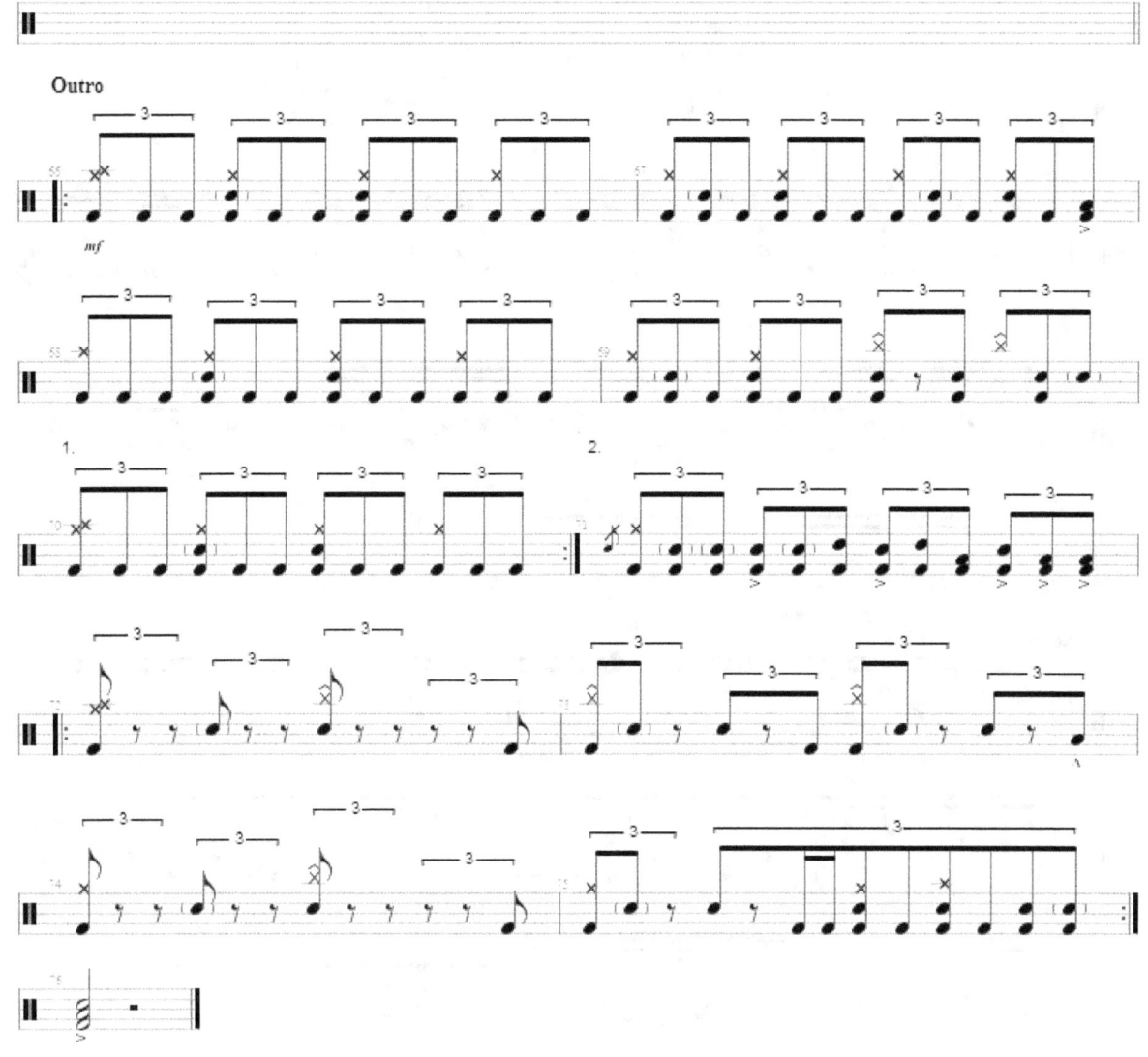

Via Calypso – Greatest Hits

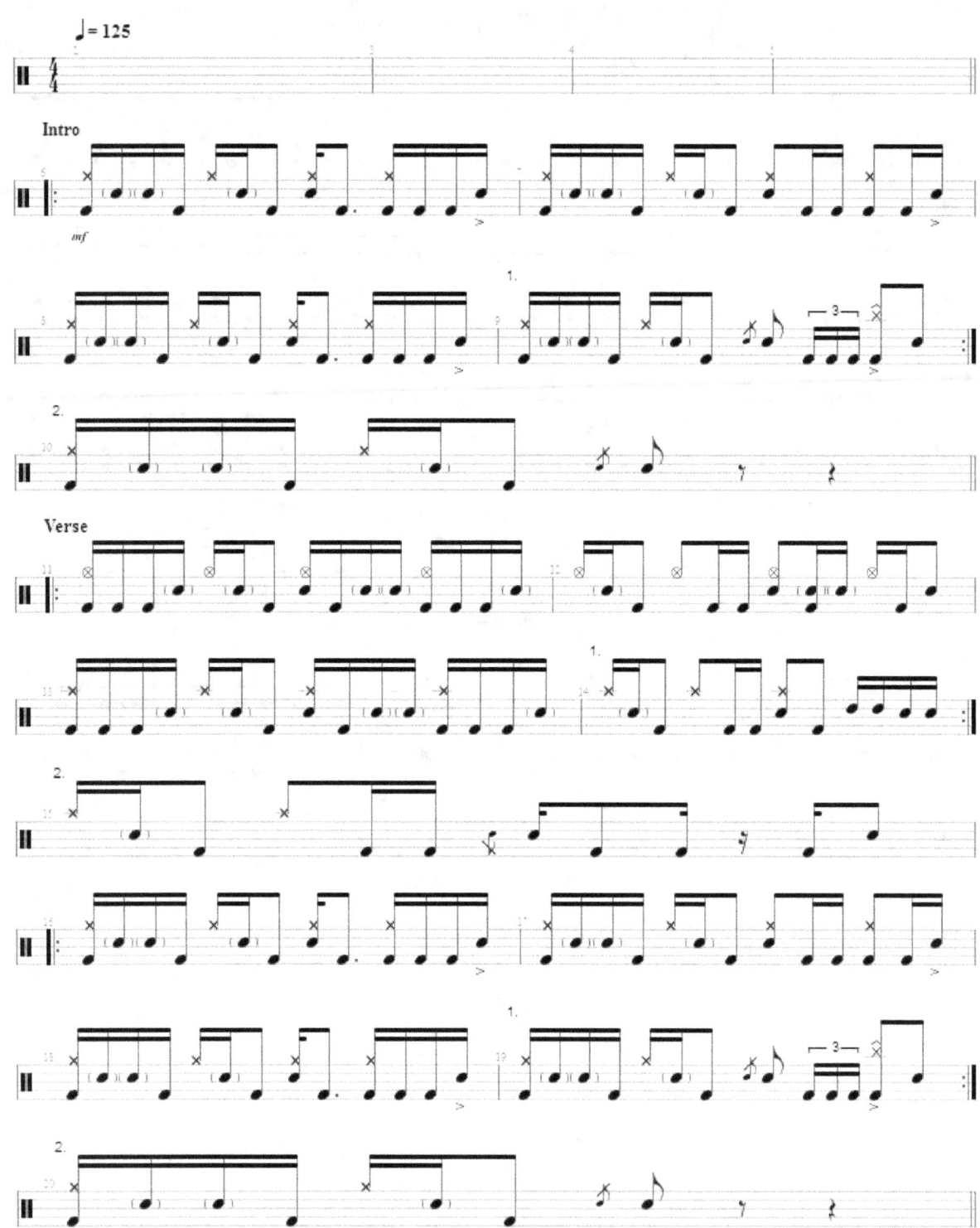

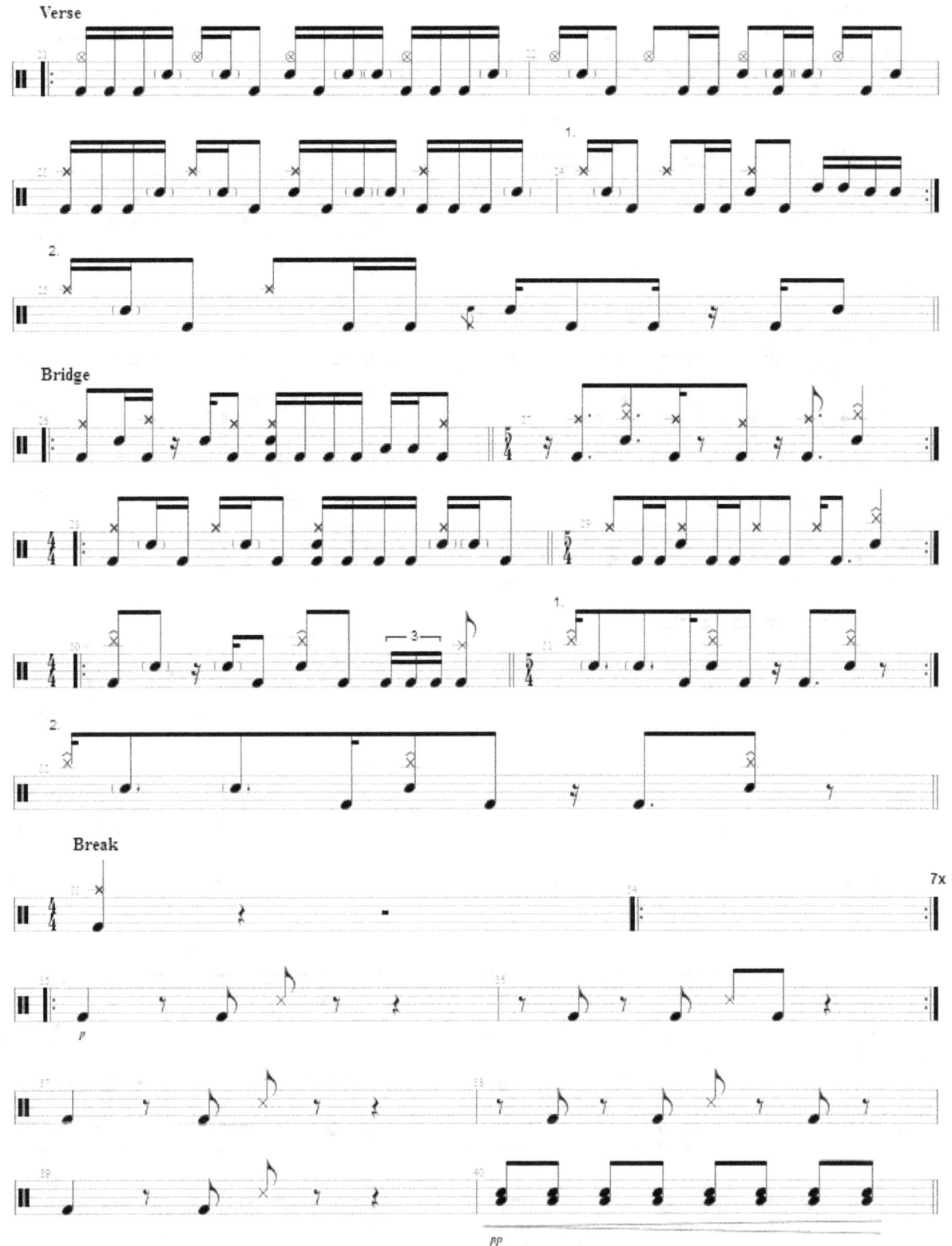

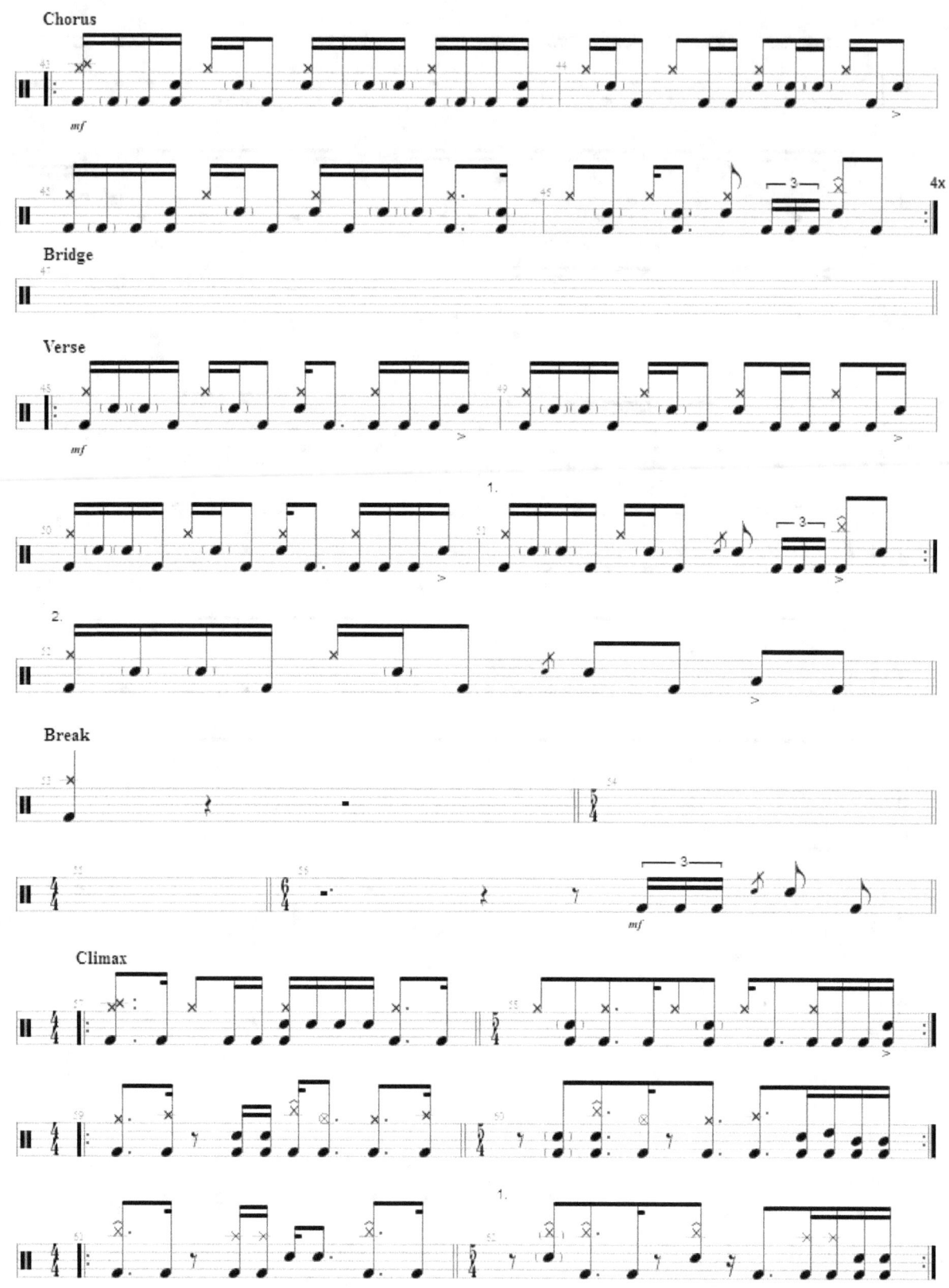

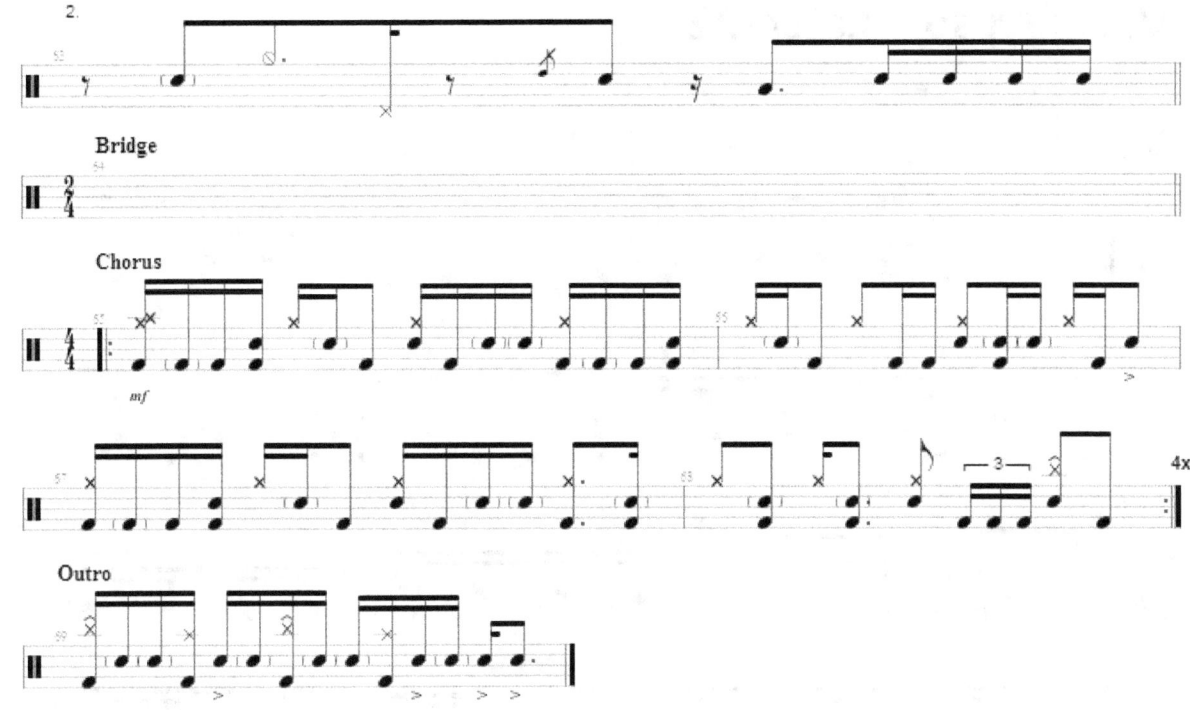

Via Calypso – Catch-22

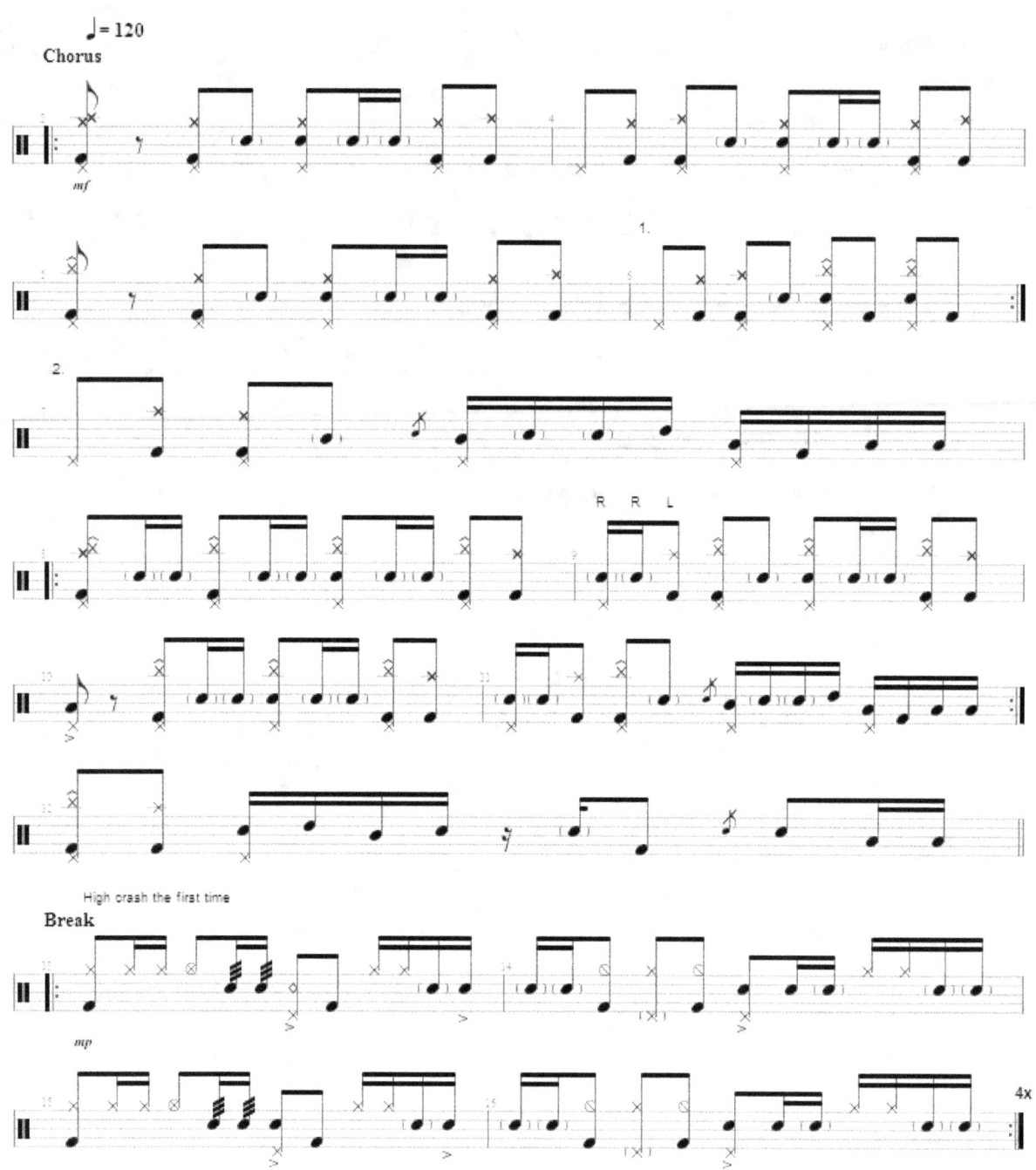

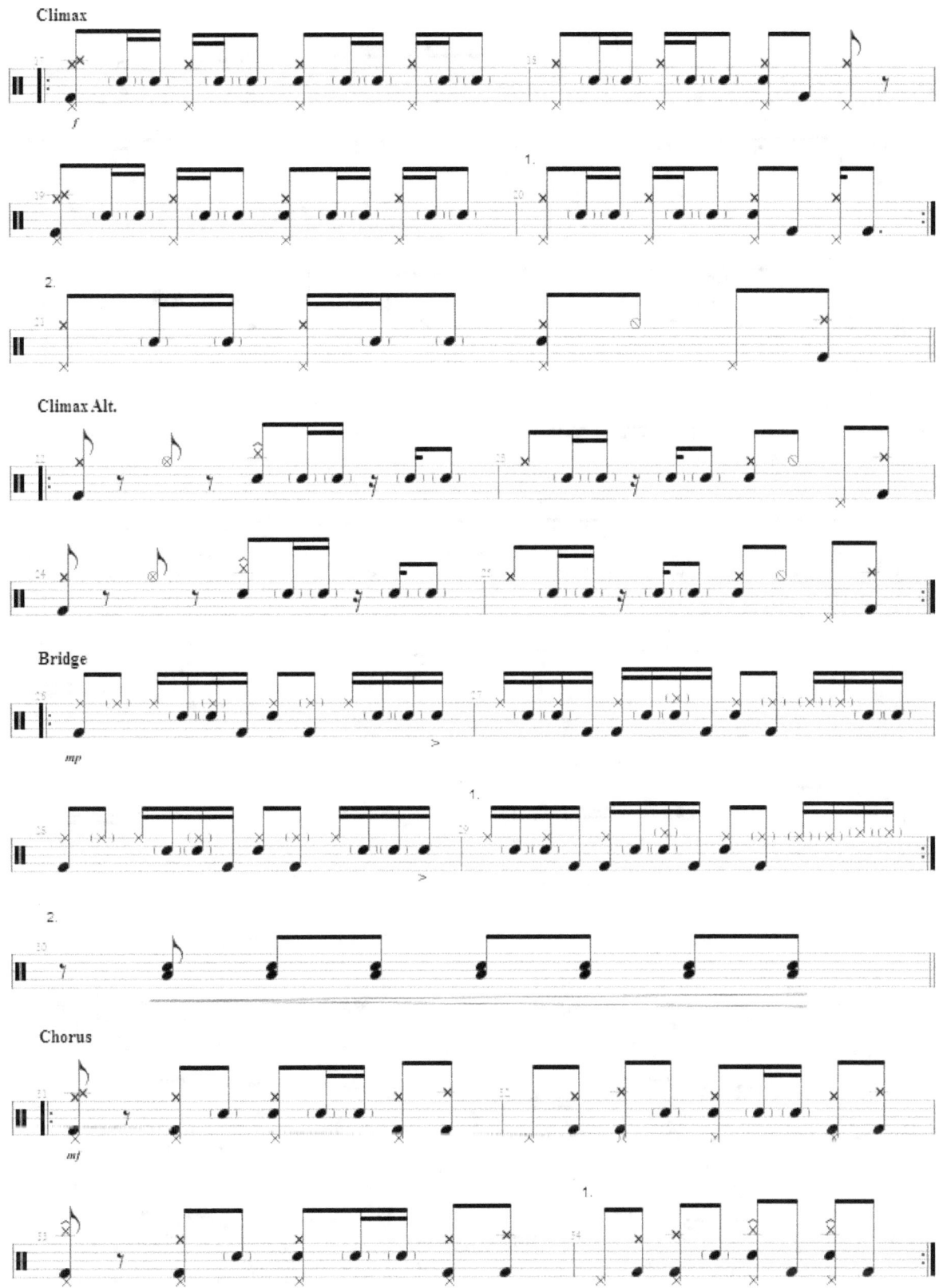

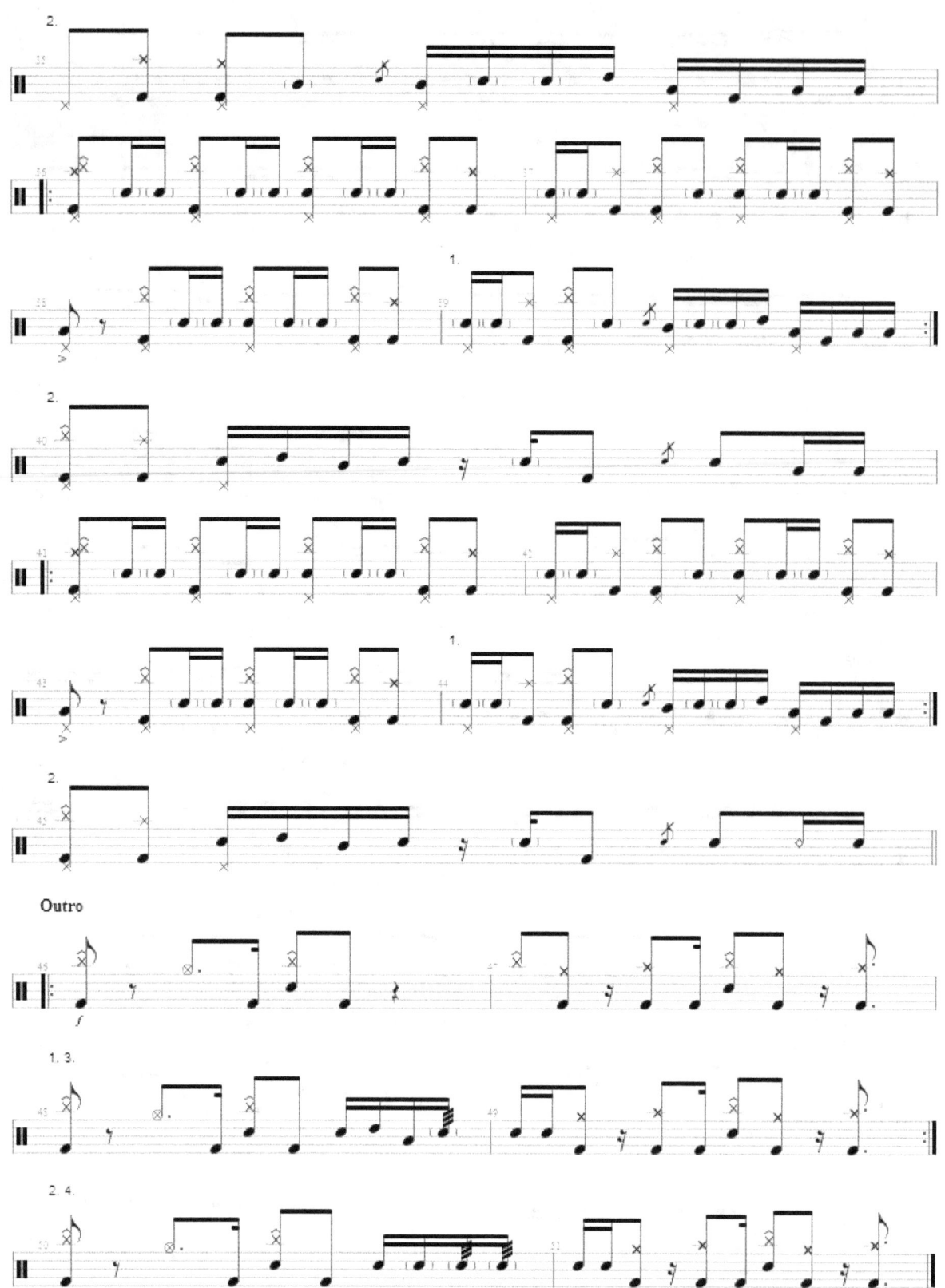

Via Calypso – Not in Portland

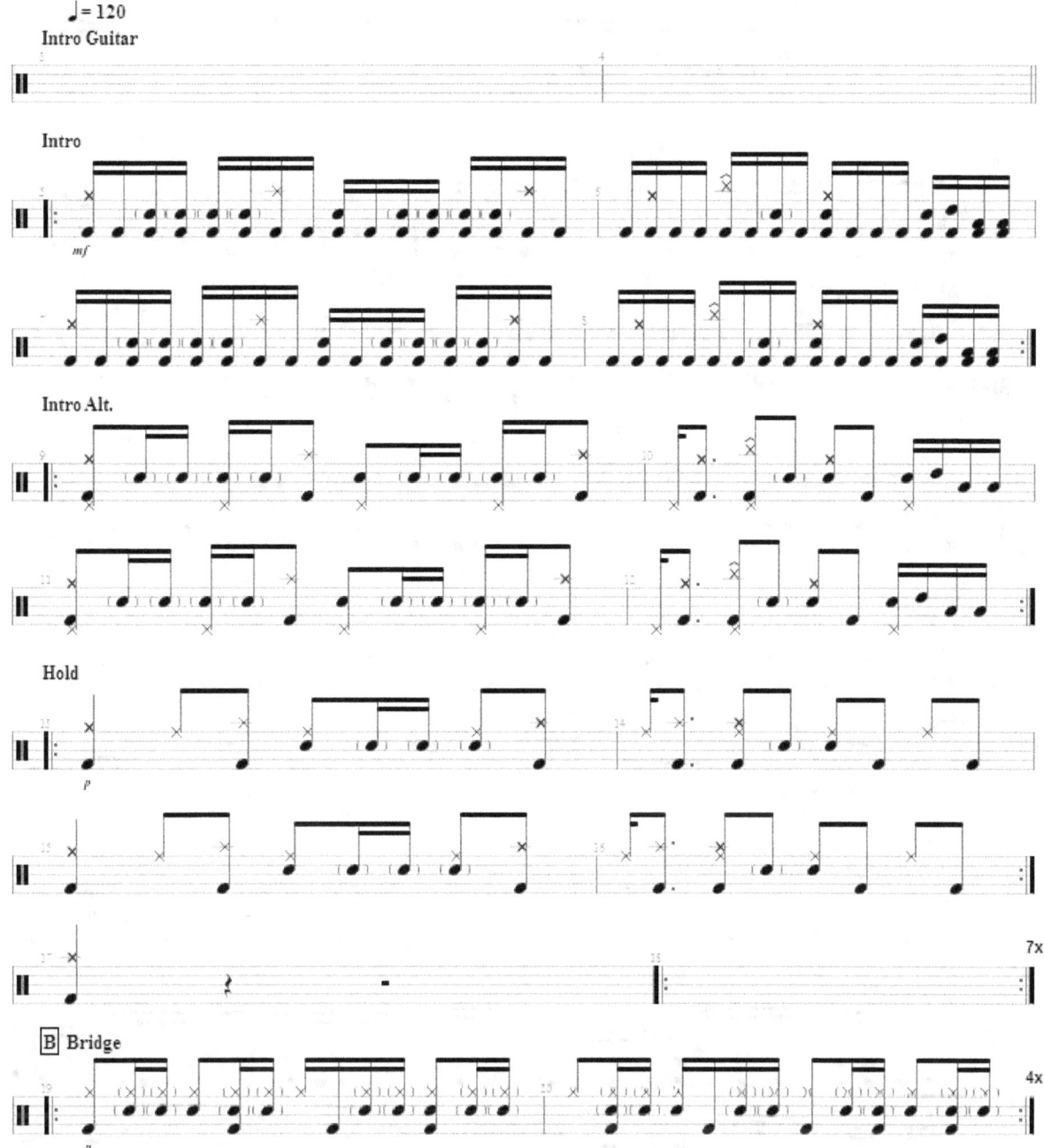

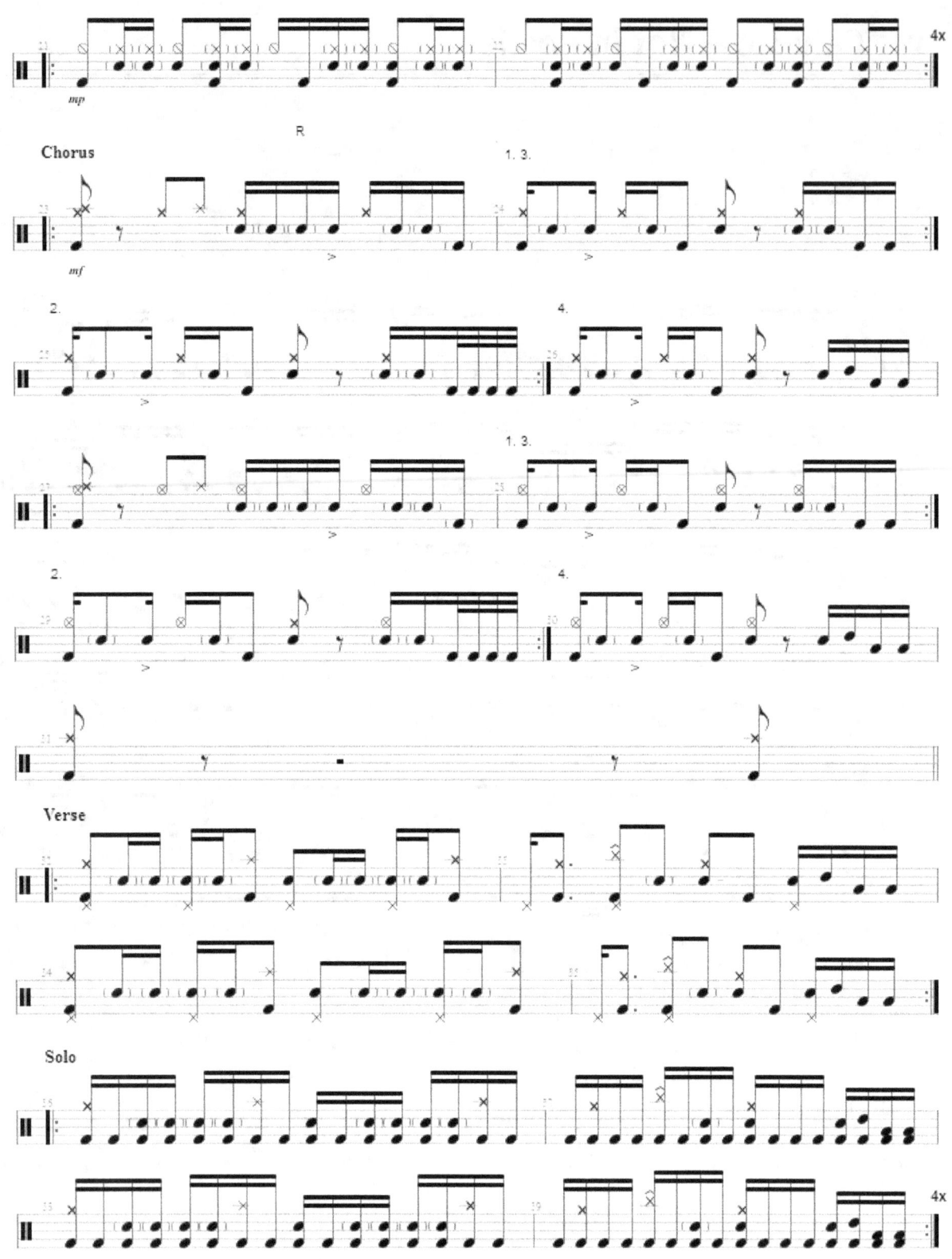

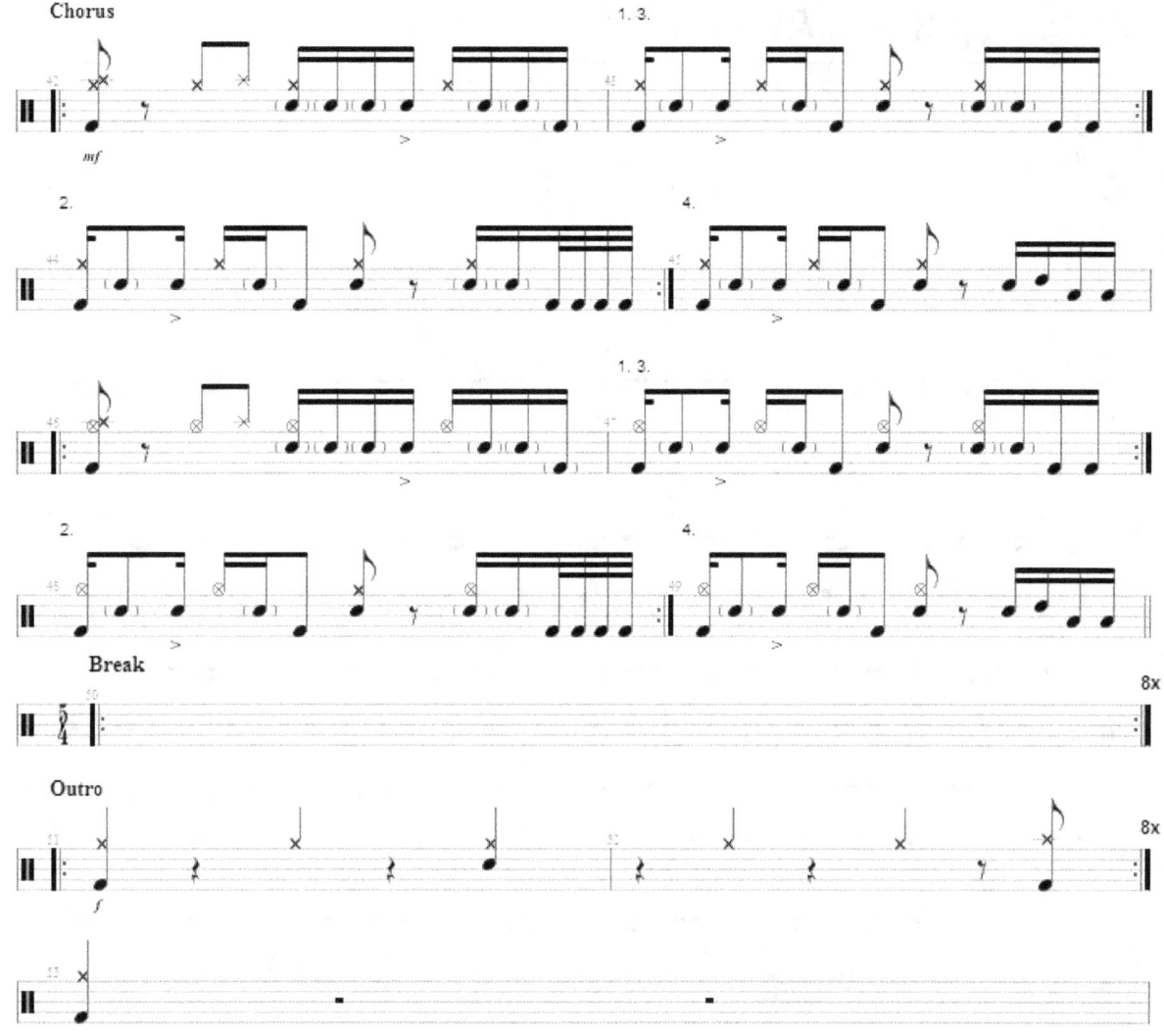

Via Calypso – ...And Found

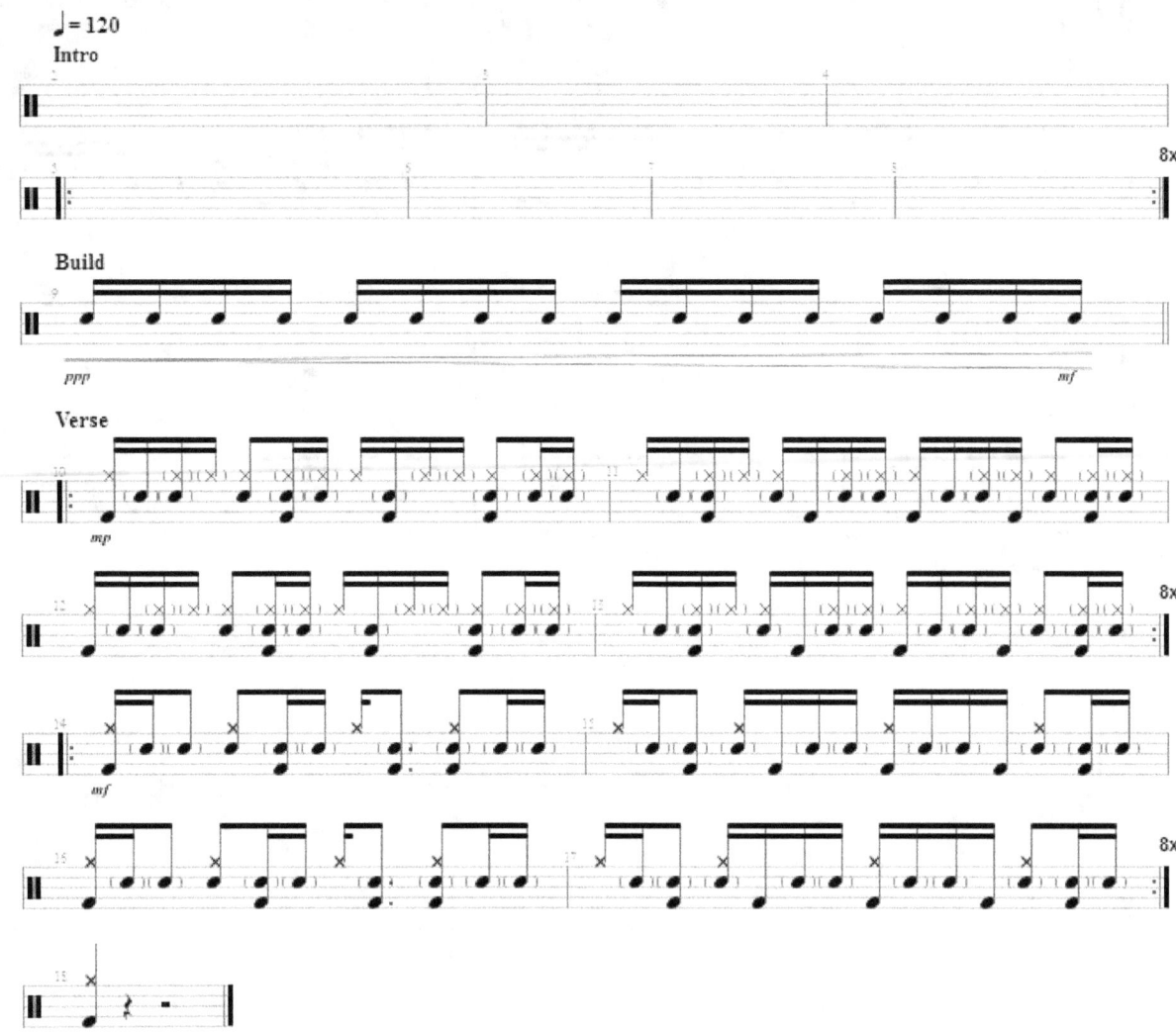

EPILOGUE

And so, we have come to the end of the book. I hope you have enjoyed the ride and are inspired to play drums even more. I have encountered a lot of people in my life whose opinion is that Percussion and Drums are "less"-instruments than others.

Don't listen to those people; build your expertise every day, learn to listen to music and most of all:

Be proud to be a drummer.

–Stijn Moreels

ACKNOWLEDGEMENTS

I want to thank my parents (**Els Pottie** and **Johan Moreels**) who supported me during the very beginning of my drum carrier. My mother for checking this book for spelling mistakes and my father for his musical opinion.

My drum teacher **Philip Carpentier** at **Drums & Co** (10 years) for the phenomenal fun and inspiring moments during our drum sessions Wednesday evening.

Julien Hauspie (my partner in crime @Via Calypso) for challenging me with his musical ideas. As perfectionists, we have the same vision about *Progressive Djent* music and how this should sound. Therefore, I trusted Julien in completely when he mixed and mastered our record (LOST). Thank you for your musical passion.

Sander Taelman (Drummer **Monopole**) for giving his musical opinion about this book and his support.

And all the other people that helped my growing as a drummer. I'm talking about professional drummers and non-professional drummers; musicians and non-musicians.

Everyone that inspires me to play drums every day.

NOTES

www.ingramcontent.com/pod-product-compliance
Lightning Source LLC
Chambersburg PA
CBHW081047170526
45158CB00006B/1887